Non-fic

A W

Michael Legat

ROBERT HALE · LONDON

ISBN 0 7090 4945 5

Robert Hale Limited
Clerkenwell House
Clerkenwell Green
London EC1R OHT

Photoset in North Wales by
Derek Doyle & Associates, Mold, Clwyd.
Printed in Great Britain by
St Edmundsbury Press, Bury St Edmunds
Suffolk and bound by WBC Bookbinders

Contents

This book is dedicated to
Alexandra and Jeremy

1 The Purpose of This Book

Some time ago I had an argument with a friend of mine. Her name is Marion (anyway, that's what I'll call her). She has been going to a Writers' Circle for many years and has produced hundreds of short stories and scores of articles and the first chapters of a couple of novels. One or two of her stories have been accepted by magazines, and some time ago a number of her articles about bygone times appeared in her local newspaper, but she has never managed to finish one of her novels, let alone get it into print. The argument arose when I called her an author.

'I'm not an author,' Marion said, quite indignantly. 'Authors are people like you, who have published lots of books – or even one book. I haven't had a book published, so I can't call myself an author. I'm just a writer.'

'Nonsense!' I said. 'An author is anyone who writes something intended to be read by other people – apart perhaps from private letters – whether it's published or not.'

The argument went on for some time, and I'm afraid I didn't manage to convince Marion that she was wrong.

Perhaps you agree with her. Whether you've been writing for years without success or have only just taken up the craft, you may be hoping one day to be entitled to call yourself an author, as defined by Marion. And perhaps, like her, you have tried your hand at a novel or two, got bogged down and never finished. Or perhaps you are always happier writing factual material. (Which reminds me of another argument I had with Marion when she said that reports, articles and similar pieces could not be called 'creative writing'. Again I said, 'Nonsense!'

7

because you need creative skill and imagination to produce non-fiction, just as you do for fiction. But that's by the way.)

In either of those cases, you might consider writing a non-fiction book. People sometimes ask me whether I prefer writing fiction or non-fiction. I tell them that non-fiction is much less hard work. Usually non-fiction writers are concerned with subjects about which they know a great deal, so most of the material is already there in their heads, and simply has to be organized and set down on paper, whereas fiction has to be invented and the story carefully constructed and the characters visualized and manipulated, which is far more difficult.

So how do you go about writing a non-fiction book? Well, I'll do my best to tell you in the pages which follow.

The main content of this manual is divided into three long chapters. The first covers virtually all the subjects which might make a non-fiction book, telling you what qualifications you will need, what publishers are most likely to be interested in, and what you should not write (unless you wish to do so despite there being very little hope of commercial publication).

The second chapter deals with the actual writing of the book, including planning, research, organization of your material, and all such matters as footnotes, the index, illustrations and permissions.

The third chapter gives advice on how to set out your typescript, how to prepare a synopsis, and how to choose and approach a publisher. There are also sections in it on agents, desktop publishing, vanity publishing, self-publishing, contracts and copyright.

If you are still wondering whether it is worth trying to write a non-fiction book, the best encouragement I can give you is to say – and it's nothing less than the truth – that it's much, much easier to get a non-fiction book published than a novel. So why not have a try?

2 What to Write About

The Qualifications for Writing a Non-fiction Book

'Can someone like me write a publishable non-fiction book?' you may ask. The answer is 'possibly', but almost certainly 'yes' if you are an expert, or if you are already famous, or if you write like a dream. Let us look at those qualifications in some detail.

If you attend classes or a course in creative writing, you will be very familiar with the advice to 'write about what you know'. I am not convinced that it is absolutely necessary to know what you are writing about if you are producing fiction and if what you mean is the background of your story. What you will really be writing about is human beings, and those you certainly do know, from yourself, your family and friends. It is quite possible to fill the gaps in your knowledge about the background, or details of fact which may be important to your story, with careful research. On the other hand, it is almost impossible to produce a non-fiction book which other people might want to read if you don't know at least the basics of what you are writing about. Research will often be necessary, and helpful, but you will use it to build on what you know already, just as in fiction you use it to provide a background for your characters. In fact, you will almost certainly have to have a great deal more than a basic knowledge of your subject – you will need, in short, to be an expert.

Now, before you put this book down in despair, believing that you can never claim to be a real expert on any subject, think again. Most of us have work experience

which gives us a considerable depth of knowledge in that field; many of us also have hobbies and if we pursue them with any determination, we know a great deal about them; in either case, research can turn us from being merely knowledgeable into being expert. So as you read the rest of this chapter and meet again and again a statement that the essential qualification for writing a book on this or that subject is expertise, don't be overawed by that word – think of it as meaning simply extensive knowledge and experience. You may wonder whether your knowledge and experience should not already be widely acknowledged, so that your name alone will add authority to what you write, but take heart – there are always exceptions to that kind of rule, and if you write a book which is not only interesting but adds something new to the world's knowledge or perception of your subject, a book which can claim a measure of originality, then it will have its own authority, your lack of reputation in the field will not matter, and you will end up by establishing your position as an expert. And if all else fails, there is always one subject on which any would-be authors can claim a greater expertise than any other human beings – and that is their own lives.

The second possibility mentioned as a qualification for writing a successful non-fiction book is to have what is known as 'a household name', which means that you are either royal, or well-known in the entertainment world, or a sports personality, or a leading politician, or famous in one of the few other spheres which will make you eligible for this title. Anyway, if your name is instantly recognizable to the public at large, you can write any old book you want to and be sure of getting it published without necessarily knowing anything at all about the subject – indeed you may not even have to write the book. That whole statement (and not just the last part of it) is perhaps something of an exaggeration, but it is certainly true that many books are published simply because the authors have famous names, rather than because they are experts in the subject, and it is equally true, especially if the author is a leading figure in the world of sport, that many books appearing under a famous name have not

actually been written by that person but by a ghost writer (see pp.32–5).

The third possible qualification for a non-fiction author whom a publisher will be delighted to have on his list is the gift of writing outstandingly well. Any author in any genre (other than the kind of famous person mentioned in the previous paragraph, who is merely posing as the creator of the book and whose book has been written by a ghost) needs an ability to put words together in such a way that the meaning is clear and that the style is not only suitable for the subject, but also for the market at which it is aimed. It is also important to get the spelling, grammar and punctuation right – these things are the tools of the author's trade and, like any tools, they need to be understood and properly used. None of this, however, is what I mean by the ability to write outstandingly well. I am thinking, in fact, of those authors whose prose is itself a delight, the mere juxtaposition of the words adding to our enjoyment of their meaning (especially if we read them aloud), and who often charm the reader further by evoking with a single word a whole scene or a range of emotion, or by giving us imagery which stirs our minds and perhaps leads us to see familiar sights in a new and exciting light. In a word, poets – true poets, whose work has a lasting appeal, and that is a fair description of such writers, even if the work they produce is in prose form.

Now, if you are already famous, you are unlikely to be reading this book, especially if you are one of those who will be using a ghost writer. If your writing is of such high quality that you can rank as a poet, then again you won't need this book, because all you have to do is to trust in your own talent. But for the authors who depend solely on their enthusiasm for the subject as the basis for producing a publishable book, some additional advice may be in order. And in alphabetical order it now follows, or will after three essential warnings, and one little bit of encouragement have been got out of the way.

The first warning is that you must understand, if you are aiming at publication, that a hardcover publisher is looking for a book which, whether it appeals to a general audience or to specialist readers, will attract buyers

(including institutional purchasers, such as libraries) in sufficient numbers to envisage a sale of probably not less than two thousand copies. That may not sound very many, but hardcover bookbuyers are a vanishing breed (except where a few bestsellers are concerned) and libraries and similar institutions are permanently short of money. The numbers will be enormously larger for a paperback publisher. It is therefore of little use to expect a publisher to fall upon your *History of the Little Muckington Amateur Dramatic Society* with cries of joy, when it is obvious that only the two dozen members of the society will want to read it (and in any case, most of them won't *buy* it, but will borrow the club copy). On the other hand, if your subject is of more general appeal, you must realize that your book may have to compete with a dozen or more on the same subject, and any publisher's interest will disappear quite quickly unless you can show that your book is attractively unlike all the others. This really is an important point. *Publishers want books which are different from, and preferably better than, the competitive volumes published by other publishing houses.* You will probably find it easier to get into print with a good non-fiction book than if your writing ambitions lie in fiction, but it still isn't easy.

The second warning is about motivation. You can, and indeed should, write for a specific market (and we shall be looking at this point more closely in a later part of this book), or you can look at a book that someone else has written and say to yourself, 'I could do that!' (which is another good way of starting – especially if you can add, 'And I could do it better!'), but nothing will work unless you really love your subject and believe in your ability to write about it. Creative writing tutors speaking of Mills & Boon romances will tell you that you won't succeed with that kind of book unless you are totally sincere – you can't write them from a distance, as it were, or tongue-in-cheek. I don't know why I and others like me confine such remarks to Mills & Boon books. It applies to any kind of book, non-fiction as well as fiction, and indeed to any kind of writing – you will not succeed unless you are sincere, unless you love your subject, unless you *want* to write the book, and unless you are determined to make it a good book.

Warning number three concerns the scope of your chosen subject. Do make certain that you have sufficient material to produce a book-length typescript. It is impossible to lay down any really firm guide-lines about the length required for a non-fiction book – the range is enormous, from under fifty words for a book designed for very young children to one million or more – but in most cases other than children's books a publisher will be looking for a minimum of 30,000 words, and would probably prefer at least 50,000. It depends on the book, of course, and I am not suggesting that you should pad your material in order to reach some arbitrary length – padding is *verboten*. The only real rule is that the book should be as long as it needs to be in order to cover the subject adequately, but you still have to recognize that if it's too short you may have problems in finding a publisher.

The little bit of encouragement which I promised concerns the fact that since all non-fiction aims to communicate information to the reader, the author is always to some extent in the position of a teacher, and especially so in respect of books written for the non-expert. If you have the ability to teach – that is, to express your facts, your ideas, your message in a clear, easily assimilated form which will help the reader to understand and to learn – then that may mean that you are better qualified in one important respect to write a book than someone who is a real expert but who is not a good communicator, although if your expertise is limited you will obviously have to aim at the beginner rather than at those who already know a great deal about the matter, and you will have to be especially careful to check all your facts and make sure that you get them right.

Now, at last, we come to the list of subjects for non-fiction books, which does not, by the way, include either drama or poetry. Neither of those subjects should be classified as non-fiction, although they sometimes appear under that heading. In fact, both – especially drama – probably have more in common with fiction than with non-fiction. But the acid test, I think, is that poets and dramatists would talk of their work as putting together a volume of verse or as writing a play, but would never refer

to it as writing a non-fiction book.

Academic Books

Many academic works do not start out as books at all, but are theses written as part of a degree or doctorate course, for which a small market can be found if the subject or the approach is unusual, if the research has been outstandingly well done, and if the whole thing bears the stamp of authority. Of course, academic books are written and published for other reasons too, and the one certainty is that they are produced almost exclusively by academics for other academics. If you belong to that world and want to write for it, you will probably be well aware of what is already available in your particular field, of the standards required, and of the degree of difference in your work which will make it required reading for your colleagues and rivals. And the fact that you are a don and highly respected in your college won't do you any harm when you are trying to impress one of the academic publishing houses.

Anthologies

Anthologies are very much in fashion at present. *The Oxford (or Faber) Book of Anything You Can Think Of (and a lot of things you would never have thought of)* has already appeared, or is about to do so. Nevertheless, if you can dream up a theme for an anthology which has not been done to death, and if you know the source material really well, you might succeed in getting a commission to prepare such a compilation. But it does need a theme – you are unlikely to succeed with a general selection of English poetry, for instance, although you might manage it if you are well-known, and especially if you already have a literary reputation. Indeed, publishers usually prefer their anthologists to have recognizable names, although there are always exceptions to the rule. It may help to think of a market at which to aim – an anthology for philatelists, for instance, or for pigeon fanciers (and as I write these words I suspect that some anthologist may be currently labouring away at such books, if they don't in fact already exist).

Art Books
In this category are included books on painting, sculpture and architecture. There is a constant demand for such works, whether they are general histories of the subject, or are devoted to the work of one artist or a particular school, or are critical essays. Naturally, they demand a high standard of expertise, and if you are to succeed in this area you will probably have devoted a large part of your life to the particular art you are writing about. You will be well aware that art books are normally highly illustrated (which means that you will have to know which illustrations will be needed for your book, and where they may be obtained) with a considerable use of full colour, and are produced in a large format. Good how-to books on painting are particularly successful, but these will be dealt with under 'Hobbies and Crafts'.

Autobiographies
As has already been said, your own life is something about which you are more expert than anyone else. Even if you may not be able to see yourself as clearly and without bias as other people, none of your relatives or friends can know all the details of your life, and especially not what has gone on and still goes on within your mind. It has been said that we cover ourselves, like Salome, with seven veils; we strip several of them off for our friends, and even the sixth veil may be removed for the benefit of our partner; but the seventh veil is never lifted, because it conceals the thoughts, the memories, the motives that we don't want anyone else to know about. Whether you will want to remove that veil, or perhaps to lift a corner of it, in an autobiography, is a question that only you can answer, but the certainty is that you, and no one else, could do so.

So should you write your autobiography? What are the chances of publication? Obviously they are extremely good if you are famous, but what if you're not? 'You've led such a fascinating life – you really ought to write your autobiography' – is that what your friends and relations say to you? If so, yes, of course you should write an account of your life, and indeed there's no reason why

you should not do so even if your experiences have not been particularly remarkable. Almost certainly, however, you will have to recognize that you are writing the book for those friends and relations who have pressed you to do so – and for yourself – but not with any real hope of interesting the general public, and so with little expectation of publication. This may seem very hard, but it is a fact of life that publishers find it extremely difficult to sell autobiographies written by unknowns. After all, would you buy or borrow such a book by someone you'd never heard of? Well, perhaps you would if the book were there in front of you, which would prove that the publisher had had enough confidence in its qualities to believe that he could persuade a large enough number of bookshops to stock it, and a large enough number of public libraries to buy copies – and that's not easy. It does happen, of course, and in a moment we will look at some of the categories of autobiography which do quite often work, even if the author is unknown.

First, however, I want to elaborate briefly on my categorical statement that you should write such a book, even if you know perfectly well that there is no hope of publication. There are several reasons for doing so.

The first is that it is probably the easiest thing that any would-be writer could choose to start on: it can be organized without difficulty on a simple chronological basis, and you are unlikely to dry up in the middle through lack of material; and the easier it is to do, the more likely you are to persevere with it and complete it. If you want to write, the best way of all to learn the craft is by actually practising it (incidentally, it *is* something that most people have to learn – very few writers are born rather than made, and most of those who are made are self-made, as a result of much practice and hard work), and writing the book will undoubtedly improve your skills.

The second reason is that you will enjoy it. We all have a certain amount of vanity, and in writing your autobiography you can give it full rein. You will be the hero or heroine of the story, and even if you are going to write in a self-disparaging way, the focus will still be on you. You

will be able to mount your soap-box too and to leap from it on to your favourite hobby-horses. You will almost certainly find that as you write your memory is stimulated, and you begin to bring back long-forgotten incidents from your past – which can be quite exciting.

Thirdly, it may prove to be a therapeutic exercise. You can write a kind of confessional, and free yourself from the burden of what you may consider to be the sins of your past. Or you may be able to relive experiences which you have always tried to forget, but which have remained to plague your memory, and this includes especially telling the story of bitter relationships, and by setting them down on paper finding perhaps that you have exorcized the ghosts.

Fourthly, although no publisher may see a large enough audience for the book to want to publish it, there are bound to be many people, such as your children and grandchildren, who will find it fascinating, and this is perhaps the best of all reasons for writing your autobiography. Don't you wish, as I do, that your parents and grandparents had left records of their lives, and wouldn't you love to read all the details of their daily concerns and their secret hopes and fears? Even if you have no descendants, there are undoubtedly other relations and friends who will enjoy reading what you have written. And one day in the distant future perhaps your typescript will be found and, because to the finders it will be a record of life in a bygone age, it will be published and will achieve the same kind of success as the diary which James Woodforde kept, published over a hundred years after his death as *The Diary of a Country Parson,* or it could provide some little nugget of information which a historian in times to come would seize upon and use in a dissertation on late twentieth-century customs. (The same arguments apply, incidentally, if you write a history of your family – a family saga, as you might say.)

Let us now look at the categories of autobiography with which you may be successful, even if you have never written before and are totally unknown to the public at large.

Firstly, if your life has truly been extraordinary,

especially if there is what could be called a 'theme' running through it (for instance, perhaps you spent a large part of your life doing an extremely unusual job in a variety of exotic foreign countries), you might find a publisher, especially if you also have the ability to write well and interestingly – but, of course, if your life has been as exceptional as all that, you may be known to the public at large anyway.

Secondly, if the background to your life is one in which the public has considerable interest and you can write engagingly about it, you have the chance to succeed and become famous even if you start as a completely unknown person. I am thinking, of course, of books like those of the vet who, when he began to write, was not widely known outside his local circle and even there would hardly have been recognized under his pseudonym, James Herriot. He qualifies as an expert, obviously, but his books are written for the general reader rather than the specialist, and their enormous success is due not so much to the fact that books about animals always have a great appeal as to his very considerable skill as an amusing story-teller.

Next, there is the possibility of publication in respect of what might be called 'inspirational' books – accounts of a triumph, through faith or strength of character, over personal tragedies, whether they concern, for instance, the death of a small child, or the courage of someone facing a terminal illness, or perhaps the determination of a child's parents to fight to give it an acceptable life despite the wholly negative prognostications of all the medical experts. The authors of such books are usually driven to write them in the hope of helping their readers to come to terms with their own similar problems. It may sound cynical to say that it is essential for the stories to be extremely harrowing and for those involved to show exceptional courage, but we are too used to a daily diet of horrors to be moved by anything less. It may sound even worse to say that the illness or problem which has to be overcome must be an unusual one, but it is probably true that so many books have now been written about people facing the big C that a new account of a cancer death is unlikely to be successful unless it has outstanding quality

in the writing itself or in the bravery involved.

Another currently popular form of autobiography is the 'nostalgia' book, in which the author recalls life, usually as a child, many years ago, using spectacles which, though not necessarily too rosily tinted, tend to show the past in terms which may surprise, but will never shock. These gentle books deal with a period which is distant enough in the past to be fascinatingly strange to modern eyes. The authors of nostalgia books are inevitably no longer young; when such accounts began to enjoy a special vogue some twenty to thirty years ago, they were usually concerned with Edwardian childhoods, but nowadays the period has moved into the 20s and 30s. Perfect recall of early memories is required for such books, since part of their charm lies in the little period details – the price of an ounce of butter in nineteen-whenever-it-was, or the sights and sounds and smells of a small village school sixty years ago.

An additional possibility – but it does demand exceptionally good writing – is the slightly fictionalized autobiography, perhaps even told in the third person, in the style, for instance, of Siegfried Sassoon's autobiographical trilogy, *The Memoirs of a Fox-Hunting Man*, *The Memoirs of an Infantry Officer* and *Sherston's Progress*. All autobiography is to some degree selective, because there are always things that those who write about themselves wish to emphasize or play down or totally conceal, and the semi-fictional approach can sometimes make it easier to manipulate the facts.

Whatever kind of autobiography you choose to write, one important piece of advice which may enhance your chances of publication is to delve deeply into your life, instead of just producing a list of events. Strip away the veils, and show us what made you what you are – which means showing us also, and in depth, the people whose presence and influence were crucial to you.

Two little points of warning: firstly, there is little hope of publication for an account of failure or one written with unflagging bitterness, because readers don't on the whole much care for depressing, down-beat stories, so you do need to have enjoyed your life; secondly, although an autobiography is inevitably an exercise in egotism, you

would be well advised to try to reduce yourself to what
Eric Linklater, in this context, called 'a little *i*'.

Illustrations may be needed. You will probably be able
to supply them in the form of family photographs.

Biographies
A strong market always exists for good biographies, but it
is not an easy field for an inexperienced author to break
into. If you want to write historical biography, a publisher
will almost certainly want to know what your qualifica-
tions are for doing so. Are you an Oxbridge don (or at least
a don of some kind)? In other words, are you an accredited
historian? If not, then you will need some other
qualification. Have you acquired access to information
which was previously unknown (a series of unpublished
letters, perhaps)? Have you something new to say about
your subject and evidence to back up your findings? Are
you the author of non-fiction books in other genres which
have been reasonably successful and which have not only
proved that you can write but have also allowed you to
establish some sort of relationship with your publisher?

If you do have some of the right sort of qualifications,
whose life do you want to write? Is there a market for yet
another biography of one of the great historical names?
Lives of Shakespeare, Newton, Nelson, Constable, Elgar
and the like, and of all the Kings and Queens, not to
mention any eminent foreigners you might think of, have
already appeared in great numbers. If, on the other hand,
you move away from the beaten track and write about Sir
Marmaduke Wobbleton, whose only claim to fame is that
he did not go on the Third Crusade, no one will be
interested. You need, incidentally, with a subject like Sir
Marmaduke, to beware of your own enthusiasms – the
fact that you have been besotted with him since the age of
seven, and that he is a household name to all ninety-seven
inhabitants of the hamlet of Wobbleton, where he once
lived and you now live, is no guarantee that anyone else
will have heard about him, or will want to do so.

There is in fact some hope for you if, provided that your
other qualifications are in order, you want to write about
one of the better known historical figures. You may have

noticed that in a great many cases when a new biography of some major historical personage appears, it does not come out by itself, but is accompanied by one or even two competitive volumes on the same subject by different authors and from different publishers. Why does this happen? Well, publishers sometimes talk of 'the ten year rule', which states that a new biography of any important historical figure can be brought out roughly ten years after the last life history of that person. It is not really a rule, and is not strictly adhered to, but you can take it as a rough guideline if you want to write in this genre. Approach a publisher with your idea for a new account of Elizabeth I about six years after the publication of the last biography of her, allowing yourself three to four years for the writing of the book, and you might be lucky.

The situation is a little different with contemporary biography, which you should probably not attempt unless you are either very well established in the field already (in which case either the subject may approach you asking you to write his or her life story, or your publisher may suggest that you do so) or unless you are a friend of the subject and have access to him or her and the family and to relevant documents and photographs, and so on. You can of course write a contemporary life without the co-operation of the person concerned, but it isn't really to be recommended. Even if you know the subject well and have his or her blessing, you may have to convince the publisher that you are the right person to write the biography, and this may be difficult unless you already have a track record as an author. It would therefore probably be a good idea to write a number of chapters of the book to show as specimens before approaching a publishing house. And do make sure that the subject is sufficiently well-known to justify a full-length book.

An interesting set of questions for would-be biographers is whether you should present your subject 'warts and all', or without mention of the warts, or particularly concentrating on them. The biographer's job is to get hold of the facts, and to present them clearly, but there is no reason why you should not, if you wish, emphasize the person's virtues or faults, provided that you do not paint a

totally false picture in so doing. Indeed, a little bias can add spice. Your task in this respect may be quite difficult if the subject of your biography is living, because he or she may not be prepared for a no-holds-barred approach, and even more so if you are writing about someone who is only recently dead, since the family may be particularly reluctant to allow you to say anything at all which they consider to be in the slightest degree derogatory. You might be able to persuade your living subject to accept a fairly honest approach, but the family is much less likely to agree, and this may apply even if you are a member of that family.

Whatever kind of biography you write, and whoever's life it may be, when you are trying to get hold of the facts, you will undoubtedly read everything available about your subject (and a great deal of background material too). You must, however, as far as you possibly can, check everything that you read to make sure that it is absolutely true – the authors whose books you consult may have got something radically wrong, either by accident or design, or may have disguised a mere surmise as hard fact, or may have copied false information from a previous biographer. Go back to original sources whenever you can.

Illustrations will probably be needed. For historical biographies you will probably have to use the same pictures that have appeared in other books on your subject's life (which might lead your publisher to decide not to include illustrations because those which are appropriate are all so well-known, and because illustrations add substantially to production costs), and these are likely to come from various museums and galleries, such as the National Portrait Gallery. For contemporary biographies, the subject or the family can usually supply photographs (often in the form of snapshots, which will have a pleasing informality, provided that they are not too blurred), and if the subject is at all famous, the photographic agencies will have files bulging with the work of professional photographers.

Business and Economics Books
These subjects are very much the purlieu of specialist

writers, who either work in the field or are journalists covering the subject for newspapers. For such writers the needs of the market will be apparent.

One area of business books which is, however, open to authors who do not necessarily have any expertise in the business is the kind of book which a company produces for promotional purposes, perhaps to celebrate its centenary or simply as a publicity exercise in which the book will be given away to its customers. It will usually consist of the story of the company's success from its founding until the present day. If you can get a commission to write such a book, the terms are often quite generous, and the firm will open all but its most secret files and archives for you. Leave your critical faculties behind, of course – what they want is a nice friendly account. So how do you get such a job? Probably only if you have already had some non-fiction books published, but it might be worth writing to any companies which happen to be approaching a notable anniversary to suggest that you could produce a book for them. You would have to make the approach at least a couple of years before the due date in order to give yourself enough time to write the book and get it into print, and you must bear in mind the likelihood that you will have to travel to the company's headquarters and probably spend a great deal of time there. You will need to convince the firm of your ability, and it would certainly help if you happened to know one of its directors and could get his or her personal support for the project.

Children's Books
Non-fiction books for children are in constant demand. It is, however, much more difficult to write any kind of book for children than you might think. Children form a very demanding audience, and one which has a low boredom threshold, a limited vocabulary, and usually a need to relate what it reads to its own experiences. In addition, you have to satisfy parents, uncles and aunts, and anyone else who might be likely to buy the books to give to the youngsters. More importantly, you have to meet the requirements of booksellers, librarians and, in the first

place, publishers, all of whom are likely to have rigid ideas of what is acceptable and what is not. Your book for children must not be sexist, racist, classist, ageist, sizeist, or any other -ist. That is what the publishers, librarians and booksellers say. I don't think the children are always particularly bothered by these things, but then I'm old and grumpy and was irreparably damaged psychologically in my childhood by reading *Little Black Sambo* and by playing with trains. What you certainly need to remember is that present-day children's books are written, as that excellent writer and teacher, Geraldine Kaye, says 'for the universal child, rather than the middle-class "nursery" child'. Although all the best writers of children's books write at least to some extent for the child within themselves, this does not mean that you can simply base your attitudes on your memories of your own childhood. It is important to know what children today are interested in, and to realize the extent of the knowledge that they gain not only at school, but especially from television.

So what qualifications do you need to be a successful writer of non-fiction books for children? Exactly those which were listed at the beginning of this chapter – you need to be an expert, or famous, or to write like a dream, and preferably all three. Indeed, if you have the ability and the knowledge to write a non-fiction book for adults, then you have the basic equipment that you need in order to write for children. You will probably have to simplify and shorten your material, and if you have the ability to teach effectively and unobtrusively, so that the child is entertained while it learns, this may allow you to write a worthwhile book based on a comparatively rudimentary knowledge of the subject rather than on a really detailed expertise. As well as avoiding all the -isms, you will have to be very much aware of the age of child for which you are writing, a factor which will affect the length, the degree of simplicity in the approach, and especially the vocabulary of your work. At the same time, however, you must be very careful to avoid any hint of writing down to your audience. Children rapidly become aware of any attempt to patronize them.

Of course, your subject matter should be of interest to

young people, but that scarcely limits the scope at all, for there are few issues which cannot capture the child's attention. Children are eager for knowledge, and while all non-fiction can be described as at least partially educational, it is particularly true of non-fiction for children. There is great scope for books which tell how things work, whether the subject is the Post Office or a vacuum cleaner or the human body. Additionally, most parents are usually grateful for anything which helps to keep their offspring occupied, so interest is always strong in books which suggest things to make, or, for instance, things to look for when out in the car.

Although the emphasis is usually on informative material, one extremely popular genre of non-fiction for children which consists almost exclusively of entertainment is joke and puzzle books. Most of the jokes are unsophisticated, and many are on the vulgar side, while the puzzles are often visual – mazes, 'which two of the six diagrams above are identical?', etc.

Large numbers of children's books are published nowadays in series. If you do your market research carefully (see pp.101–2), you will discover the kind of length and approach which publishers are looking for. You will also be able to see the range of subjects available, and make some assessment of whether any of your own ideas for a book would attract a publisher's interest.

Virtually all books for children require illustrations. For non-fiction, photographs may be very acceptable, but paintings, drawings and diagrams may also be used, according to the nature of the subject. If you can prepare these yourself, that will be helpful, but do make sure that the standard of your artwork or photography is of the same quality as that which a good professional would produce.

Cinema, Theatre and Television, Books on
Of course we are not concerned here with writing film scripts, plays or material for television, but with books about the cinema, the theatre and television, and (although this may impinge on biography) about those who work in it. Clearly, considerable expertise is required,

and indeed the author of such books is likely to be part of that world, whether working inside it or viewing it from the distance of the critic's seat.

Illustrations will almost certainly be needed, in the form of photographs.

Computer Books
As all owners of PCs (personal computers) can tell you, the manuals that come with them are frequently confusing and impossible to understand. As a result, a large number of books, each devoted to a different make or model of computer, has been published, and of course these include not only manuals but all manner of instructions on how to get the best out of the computing hardware and software that you have. There are also many books on desktop publishing (see p.100), which depends on the use of computers. Since ownership of a computer is growing rapidly, and since the machines develop and change almost daily, it would seem that the market for books about computers is an expanding one. But of course, many of these books are written by professionals within the manufacturing industry, and if you are not in the business yourself you really do need to have become an expert, understanding all the facilities available in any particular model, and the use to which they can be put, not to mention the technical vocabulary. And you must remember that, if your book is intended for the average user of a home computer, you cannot take any technical knowledge for granted, and must therefore give your instruction in the simplest of language and explain any necessary technical terms fully and clearly.

Cookery Books
An insatiable demand for cookery books seems to exist, and comparatively little originality is required (the instructions for the preparation and cooking of basic foods like pastry or roast beef tend to be pretty much the same in all the different cookbooks, while one often suspects that recipes for more exotic dishes are copied by the various authors from each other), although naturally you must avoid any possibility of a charge of plagiarism by

expressing everything in your own terms rather than those of other people. What is absolutely necessary is that all the recipes should work, which demands not only accuracy in the listing of ingredients and clarity in the preparation and cooking instructions, but certainty that the result will be good to eat, even if some of your recipes may be too rich to be really healthy. So every recipe must be tested by the author with the utmost care.

Cookbooks abound, and new ones appear regularly from many publishers. So how do you persuade a publisher that yours is exceptional and worthy of publication? Unless you are a TV cook or a chef with an international reputation, you will probably not have any luck with a *Complete Cookbook*, especially since magazines like *Good Housekeeping* and institutions such as the Gas Board or the Women's Institute and mail order businesses like *The Reader's Digest* frequently produce comprehensive cookery books which are compilations from many authors rather than the work of one person. You might be able to interest a publisher if you have a collection of original recipes of your own invention for mouth-watering food, but the safest answer is to specialize and to aim at a limited market with books such as *Catering for Seven-and-a-half-year-old Children's Parties* or *The Book of Garlic Cake Recipes* or *Cooking for People with Three Legs*. Those titles may be a little bizarre, but the potential range of specialized cookbooks is virtually unlimited (but although you think it would be a jolly good joke to produce *The Lucrezia Borgia Cookbook*, full of recipes which would be deliciously fatal, I doubt if you would get it published – at least not without so many warnings not to begin even to think of using such noxious ideas that the joke would be ruined).

Diet cookbooks (which could, of course, come under the heading 'Health') almost deserve a complete section to themselves. Again, there is competition from organizations such as Weight Watchers and the Slimmers Club, but there is also room for individual authors – look at Rosemary Conley and her *Hip and Thigh* diet books. You need to be very careful, of course, that any dietary plan in your book is medically sound and will not harm anyone

who follows it. However, it does not seem to be necessary always to prove that the diet will actually result in a loss of excess weight. So, provided that it will not make its adherents ill, or even off colour, there seems no reason why you should not produce your *Lose Weight while Eating Cream Cakes Every Day Cookbook* or, for the opposite effect, *The Enlarge-Your-Bust-Measurement Cookbook*. It is quite important to find an attractive title, if you can.

To be serious, however – and cooking is a serious business – the really vital ingredient that you must bring to the preparation of any diet cookbook is a belief in the validity of what you are doing, so I am not really suggesting anything as cynical as the last part of the previous paragraph might suggest.

Wine books are often listed under Cookery in publishers' catalogues and in booksellers' lists. This is not because the differences in the nature of the contents are not recognized, but simply because books cover such an enormous number of subjects that some kind of grouping together, however arbitrary, is often helpful within the book trade. Wine books are usually written by oenophilists, if not oenologists. In other words, you do have to be an expert, and you do have to have something worth saying – preferably something which none of the other wine-lovers or wine-experts have already said.

Colour photographs of luscious-looking food are *de rigeur* for general and diet cookbooks, and views of vineyards, wine-filled glasses and the like, though not essential, are often used in wine books.

Criminology Books

True-life crime and criminals have a fascination for the reading public. These books are usually written by journalists or by ex-police officers of high rank, though occasionally well-known authors from other spheres are tempted by the extraordinary fascination of murder or large-scale crime into writing on the subject. Such books cover not only recent crimes, but often delve into famous murders of the past, especially those which have never been solved and those which came to a controversial trial. The market is a good one, and this genre is worth

pursuing if you have a serious interest in it, even if you are not in the categories of writer already mentioned, especially if you have made yourself an authority on a crime which is of an involved and interesting nature, and which has not been done to death already.

Illustrations, often available from picture agencies, are usually required.

Educational Books
Educational books, designed for use in schools, are invariably written by teachers, and usually for one of the best reasons for writing anything – to do it better than it has been done before. So a new arithmetic or French or biology textbook is produced because the teacher who has written it has devised a course, a way of teaching the subject, which differs from and improves upon the courses laid down in other teachers' books. The problem with new textbooks is not merely one of persuading a publisher that your material is different and better than anything else available, but of getting your fellow teachers to agree with this assessment to such an extent that they will actually want to use your book, so that it will become 'adopted' by schools in sufficient numbers to make publication viable. (Incidentally, if the new textbook *is* adopted, it may go on selling in substantial quantities for a number of years, and although the royalties paid on educational books are usually much lower than those on ordinary 'trade' books, the author may do very well indeed financially.)

One special area of educational books covers works designed for adults rather than schoolchildren. This includes many of the books which are intended for use in the teaching of English as a second language (i.e. teaching people whose native language is not English). Again, it is obviously a specialist field, and only teachers are likely to be equipped with the necessary knowledge and desire to write such books.

Not all books which come under the Educational heading are textbooks. Many are about education itself, its methods, its politics, its past, its present and its future. Such books, yet again, normally come only from those in

the business, or from historians.

Environmental Books
Books about the environment, which have become very
popular in recent years, are usually written by authors
who come from one of two basic groups: on the one side
are the specialists who can produce authoritative books on
the effects that deforestation will have, the growth of
deserts throughout the world, the present levels of
pollution in the seas or the rivers or the cities – their books
will probably be densely argued and full of tables and
charts, and will quote reports from various international
bodies; on the other side are the emotionalists who write
with passion for a much wider, general market. This is not
to say that authors in the latter group can write
successfully without any expertise at all – indeed some of
them may be highly qualified scientists – but there is
clearly not the same demand for intense expertise,
because at a popular level the subject is fairly easy to
research, and the author's emotional involvement is the
main requirement. Travel to South America and write of
the threatened rain forests if you care about them and can
afford it, and you may be able to get your book published.
It is not, however, essential to do anything as exotic as that
if you want to make a plea for conservation in the form of
a book – the hedgerows of our English countryside
provide argument enough and may even be more
attractive to a publisher and to the public than yet another
book about the Amazon.

Illustrations are always required for books about the
environment, and both colour and black and white
photographs are often used.

Fashion and Beauty Books
Although you might think that the authors of books of this
type will be drawn exclusively from those journalists who
edit and write fashion and beauty articles for women's
magazines, and that the books will be devoted to the
dernier cri, and will therefore inevitably be ephemeral, in
fact this is not so. The reason is precisely the existence of
those women's magazines, which means that the latest

fashions in clothes and cosmetics are adequately covered in a medium which can be produced much more quickly than is normal for a book, so that it can be up-to-the-minute in its information. A few here-today-and-gone-tomorrow books on current beauty and fashion ideas may appear, usually written by specializing journalists, but the historical approach – fashion through the ages, make-up through the ages – or a manual on unchanging aspects such as the basics of dressmaking or skin care are more likely to attract a publisher. Some degree of expertise is obviously required, but if you want to write in this sphere, you almost certainly also need some standing in the fashion and/or beauty business which will give your work a ring of authority.

Illustrations will be essential. Photographs will be used, and sometimes fashion designer's sketches. If you are writing a history in this field, your own pen and ink drawings, or something equally simple, may be adequate, provided that they are accurate and of a good professional standard.

Gardening Books

Gardening is almost as popular a subject for books as Cookery. The famous names in the business – the radio and television gardeners, and some of the well-known growers, and leading lights in the RHS – are likely to produce sufficient books on general aspects of the subject to meet the needs of publishers and of the market, especially since their efforts are supplemented by the regular publication of large, lavishly illustrated gardening encyclopaedias from sources such as *The Reader's Digest*. The one hope for authors who are not already part of the magic circle is specialization – if you are an expert on, let us say, hydrangeas, it may be worth your while, even if you are aware that Mr Greenthumb, the TV gardener, has already published a book about them, to approach the kind of publisher who brings out a series of gardening books, each devoted to a different flower, if there is as yet no book on hydrangeas in the series. Another possibility exists if you have developed an expertise in some rather unusual aspect of gardening – making the most of a small

and very oddly shaped garden, for instance, or possibly persuading plants to grow in the kind of soil which they normally hate. It is also worth remembering, as with a number of other subjects, that while gardening books are generally written for fanatics, who are prepared to spend both money and time, and to take infinite pains (or at least think that they will do so) in their gardens, there is undoubtedly a big market consisting of those who want to be told how to get a reasonable effect with the absolute minimum of effort, and an even larger market of dead-beats who want to be told how to get a perfect result with no effort at all.　　Illustrations in the form of colour photographs are essential, and there may be a need for diagrams too.

Ghost Writing

A great many would-be writers appear to be intrigued by the idea of ghost writing, believing that it is an easy way to make one's entrée into the ranks of published authors. Their argument goes like this: I am a competent writer, in the sense that I can string words together and produce something quite readable; I am interested in writing non-fiction, but my problem is that I don't know what to write about, having no particular expertise, and I do not want to have to undertake a vast amount of research; that problem would be solved if I were to write a famous person's life story, when all the material would be ready-made; I realize that no publisher would be interested in commissioning me to produce such a biography, because my name is unknown and I have no track record, but if I were to write the life story of some famous contemporary as though it were in his or her own words (which is the essence of ghost writing), then my own obscurity would not matter; moreover, since my subject would be involved in the project, he or she would provide all the facts I should need, without any necessity for research. It sounds a reasonable enough argument. Unfortunately, it's no easier to get into print as a ghost writer than in any other authorial capacity, and ghosts do need special qualities.

How do ghosted books actually come into being? Let us

assume that a publisher sees good commercial prospects
in publishing an autobiography by the newest star to rise
above the horizon of the sports world; the publisher
approaches the star, who may be far from unintelligent
but not really capable of writing a sustained piece of prose,
or may turn out to be totally illiterate, having left school
without having been trapped into learning anything at all;
in either case, the publisher's initial hope of a genuine
autobiography has been dashed, but the star is willing for
a book to be produced which will go out under his or her
name; the publisher now looks for a ghost writer, which
means someone who can satisfy a number of
requirements:

Firstly, it must be a writer of a certain proven ability – a
journalist, or possibly the author of a book or books of a
general nature, which have preferably enjoyed only a
modest success (so that their author is not particularly
well-known, nor likely to want only to continue to write
his or her own books); secondly, the ghost will probably be
fairly hard up, and therefore contented with a modest
return from the work, because ghost writing is not all that
well paid; thirdly, the ghost must not have an over-inflated
ego, partly because it will be essential to allow the subject's
vanity to have free rein without competition from the
ghost, and partly because the ghost may not even be
named in the book, other than in a note of thanks from the
'author' – although nowadays it is usual to use some such
wording as '*My Life* by A— B— (the star), *as told to* Y— Z—
(the ghost)' or '*My Life* by A— B— *with* Y— Z—', but in
either case the ghost's name will be in much smaller type
than the star's; fourthly, the ghost must be someone who
will be compatible with the star, so that the two of them
will be able to work together amicably over long periods
while the ghost is extracting every possible piece of
information from the subject; fifthly, the ghost must be
capable of editing the huge amount of material obtained
from the subject, and shaping it into an effective narrative;
sixthly, it will be essential, for the ghost to have some
interest in the sport and a basic knowledge of it; and finally
(and this is the really vital qualification), the ghost must
have the ability to sink his or her own personality and

assume that of the subject, so that the book really sounds as though it were the subject who wrote it – a ghost is in fact rather like an actor, but one who works with the written rather than the spoken word.

It will be apparent from all this that ghost writers are rather special people who have an instinctive liking and aptitude for this kind of work, and who might be described as literary chameleons. The chances of a new and untried person being given a ghost writing assignment are very slight, however talented in this direction they may be. But even those who are 'naturals' have to start somewhere, so how is it done? In many cases, I think, the publisher may ask the subject of the proposed book whether he or she knows a writer who could undertake to 'help' him or her with the book, stipulating of course that the writer must have a track record of some kind. So if you want to be a ghost writer, get some work of some kind published somewhere, then become friendly with as many celebrities as you can, and try to persuade them to give your name if the right circumstances arise. And if you have actually published a book, let your publisher and your agent, if you have one, know that you are seriously interested in the idea of ghost writing. Alternatively, it might be worth writing a chapter or two of what would appear to be the autobiography of some major public figure who interests you, even if you did not have the benefit of information from the celebrity concerned, finding out sufficient details of his or her life to make the chapters sound convincing; you could then try showing them to publishers as evidence of your ability, asking to be kept in mind for any future ghost writing assignments.

The financial arrangements for ghosts vary from case to case. Usually the advance and royalties will be split, in differing proportions according to the eminence of the subject and the experience of the ghost, or the publisher may offer the ghost an outright fee (which the ghost would be ill-advised to accept, a royalty, even if small, being preferable). Sometimes, however, the publisher takes no responsibility for the ghost's remuneration, and it is the subject who pays him or her according to some

formula agreed between them. Again, the ghost should not agree to a one-time payment. Obviously, in any of these cases the ghost will need to have a contract setting out all the relevant terms.

Illustrations will be needed. The subject of the ghosted book will probably be able to supply family photographs, and other pix will be available from photographic agencies.

Health Books
Under this heading I am not concerned with serious works aimed at surgeons, doctors, psychiatrists and nurses, which appear under 'Medical', but with books intended for consumption by the public at large. Fifty or sixty years ago, although simple medical dictionaries written for ordinary family use were quite popular, far fewer books on health were published. There was nothing approaching the present general interest in what might be called 'healthy living' – an interest amounting to an obsession, caught (if obsessions can be caught) from our neurotic cousins in the United States. People might have liked the idea of 'keeping fit', but they did not generally worry about it as we do today. They had little knowledge of or interest in preventative medicine, or any awareness of the possible effect of their life-styles upon their health – it was not generally accepted, for example, that smoking was dangerous, and the man and woman in the street had never heard of cholesterol. Nowadays, books about health are published in large numbers, mostly warning their readers against the dangers of various habits or foods, or proposing régimes designed to make the reader fitter and more disease-resistant. Although most of them are written by doctors or otherwise qualified persons, there is also room, especially in the field of various long-term illnesses or handicaps, for books by the sufferers or members of their families advising others on how to cope with the difficulties.

Many of the books aimed at the general public are nevertheless fairly specialized, concerned perhaps with children's illnesses, or with pregnancy and birth, or with PMT, or with AIDS. It is almost certain that, if you want to

write this kind of book, you will be medically qualified, but in some cases a lay person may succeed, if he or she has experience of the subject and a new approach to put forward, offering useful but non-medical advice.

Another area of health in which many popular books are published is psychology, and among them I include not only the kind of work which sets out to discuss body language, for instance, or to explain in non-specialist terms such conditions as agoraphobia, but also what might be called self-help books. Many of the latter come from the United States, the most successful example in the genre being Norman Vincent Peale's *The Power of Positive Thinking*. The qualifications for writing such books often seem somewhat flimsy, and if you have a good idea which can be turned into a book on these lines, promising success, happiness and possibly even health too, then you should undoubtedly go ahead with it, even if you are not a doctor or a psychiatrist, nor otherwise qualified. Your book should of course have some serious ideas to offer, and if it succeeds in boosting a reader's self-confidence, then its publication is justified.

Many books are also devoted to alternative medicine, ranging from the respectable to the cranky, and, provided that what you write is in no way harmful, there is nothing to stop people without any medical training from entering that field too.

By far the largest numbers of popular health books are concerned with our eating habits. Those who were brought up in the years before during and shortly after World War II had no doubts about food values – rich food was good for you, if you could afford it, and there were positive advantages in consuming large quantities of butter, cream, sugar and eggs, and dishes made with them, not to mention red meat and even alcohol. Nowadays, it is almost impossible to pick up a newspaper without discovering that some foodstuff which has been enjoyed for centuries is currently considered to be very bad for you. Consequently, a constant stream of books appears suggesting how to enjoy a salt-free, sugar-free, egg-free or anything-else-free diet, or how to reduce your cholesterol levels, or how to retain your youth by eating

honey and ginseng, or to increase your brain-power or your sexual drive with some other eating programme. These books are not necessarily diet cookbooks, and may include much information and instruction in addition to recipes. Many of them are of little value, do not fulfil their claims and soon disappear. More serious and more valuable, at least to their growing numbers of practitioners, are the books written for vegetarians and vegans. But most of the books in this category are concerned solely with losing weight. Obesity is medically unsound, but far more importantly, is unacceptable socially, and despite occasional efforts to prove that it's OK to be fat, huge numbers of more or less huge women, and unhuge numbers of more or less huge men, spend vast amounts of money, time and energy in trying against their natural inclinations to become sylph-like, and mostly for purely cosmetic reasons. Books of slimming recipes, exercises and magic formulae sell like hot cakes. It is better to have some qualification for writing such books, but if you haven't any letters to put after your name it doesn't matter very much, provided that the régime you put forward is not actually bad for you. Of course, if it happens to work, you may be on to a very good thing indeed.

History Books
Don't try to write a general history book unless you are qualified to do so, which almost certainly means that you are a professional in that field (probably a university or school teacher), and if the mere mention of your name will lend authority to your work that is obviously an advantage. Similar qualifications are still needed for books on contemporary history, but teachers may be joined by politicians and even journalists.

A specialized history, as for example of a religious, political or trade union movement, or of a sport, of fashion, of medical discoveries, or of any number of other subjects, will probably demand expert personal knowledge, but not necessarily any fame, and the more esoteric the subject, the truer that statement. (In many cases, the possibility of writing a specialized history will be mentioned under the different headings in this list of

non-fiction subjects.)

Illustrations will probably be required, including both drawings and photographs.

A real chance for the new writer lies in books of local history. If you write a history of the town or village where you live, you may not find a commercial publisher to take it on, because the potential market is too limited, and even if the sale of a substantial number of copies to tourists can be envisaged, these will usually have to be at a fairly low price at which the publisher's economics would not work. But you may be able to find a small local firm – perhaps a printer rather than a publisher – which would be prepared not only to manufacture your book, but to publish it too. Or you could publish it yourself, especially if you have the kind of computer which will allow you to produce desktop quality work (see p.100). Research for such a book should be comparatively easy, even if it needs to be intensive – access to records of various kinds is usually available, not only in the immediate vicinity, but also in county archives, and there may even be an existing local history which you can bring up to date. (But do check to make sure that it is out of copyright. If it is not, you can only use those facts in it which are generally known, writing your own original version of them – and please note that if you take facts from a copyright book which could only have been obtained from that book, you will need permission to use them.) You should also be able to supplement any documentary evidence about the more recent past with the memories of people who have spent all their lives in the locality. Don't forget, however, to check and double-check all details for accuracy, going back to original sources whenever possible.

Illustrations will probably enhance the book. You might look for drawings by a local artist, as well as, or in place of, photographs.

The comments in the last two paragraphs apply if you write a family history or the *History of the Little Muckington Amateur Dramatic Society* which I instanced in the early pages of this chapter. Such books won't find a commercial publisher (although your family saga might if you come from a *very* distinguished line), and it may prove too

expensive to have the books printed yourself because of the minimal quantity required. Nevertheless, some market exists for such works, and you may be able to produce copies by running them off on a word processor or by using a photocopier, and then having them cheaply spiral-bound, or even simply stapled.

Hobbies and Crafts, Books on
Provided that the craft, hobby or pastime in which you are interested has a reasonably large following nationwide, it is likely that substantial numbers of books about it have already been published. However, there is nearly always room for more. Of course you need some expertise, and the better known you are among other devotees of the subject, the easier it will be to get a publisher to accept your book. It is obviously an added advantage if you have something new and interesting to say, or can perhaps explore in detail one particular aspect of the subject. However, since a large proportion of those who are hooked on any hobby or craft want to read and usually possess all the available books on their particular interest, the fact that you are unknown will not necessarily deter a publisher, provided that your book is clearly written and offers even a slightly different angle from its competitors (but remember that publishers do like books which differ from competitive volumes). Possible subjects cover a very wide spectrum, from flower arranging to calligraphy, from model railways to origami, and there are also crafts which could be included under other headings in this list of non-fiction subjects – a book on pottery, for example, might be classified under 'Art books', and one on dressmaking might come under the 'Fashion' part of 'Fashion and Beauty'.

The most popular subject is undoubtedly gardening, which has already been separately dealt with, but another, almost as important, is needlework, which covers knitting, embroidery, patchwork, soft-toy-making, tailoring, and dozens of other variations, and has the advantage that every book can provide its readers with patterns which differ from those published elsewhere, even if only in detail. Pets and fancies breed many books, including

manuals and histories devoted not only to every variety of dog and cat, cage bird and fish, but also to far more exotic creatures (see also 'Pets', later in the list).

Yet another very popular hobby is painting, about which an unending list of books appears year by year. There is a wide range to be covered – all the various media from oils to gouache to water colour to pencil, and a vast number of specialized techniques from composition to the application of a wash. And there are books on landscape painting, portrait painting, flower painting, and so on. You name it, there's a book on it – but don't let that stop you if you are equipped to enter the field, because the demand is insatiable.

Most, but not all, books of the kind so far discussed will need illustrations.

The subjects covered above are all activity-related, with the reader growing or making or looking after or producing something (to add to the list you might look at the courses on offer under your local Adult Education scheme), but many hobbies are based on collecting, a habit to which the human race is much given. Almost anything can be collected, so the subjects range very widely indeed, and of course in this area must be included antiques, interest in which has grown enormously as a result of the television programme, *The Antiques Roadshow*. Books for collectors can deal with the history of the collected item, or may be rather like a catalogue, listing and illustrating all the known varieties of whatever it may be. They are quite often highly specialized, written for people who already have a considerable knowledge of the subject, but if you should start collecting something which nobody else has ever thought to be collectable, and the idea catches on, then you may be just the person to write a book on the subject.

Very many publications in the field of crafts and hobbies are 'how-to' books, which aim to help their readers to practise and improve their skills. They are often intended primarily for the beginner, or are suitable both for those starting off and those who have had a certain amount of experience but cannot consider themselves expert. The dozens of books intended for would-be writers are a

perfect example. The majority are written by authors who have had several books published and who have had considerable experience as tutors of creative writing. Some of them provide an introduction to the writing business and cover, briefly, as many aspects as possible – from fiction to journalism, from poetry to children's books, and also such varied matters as libel, the preparation of the typescript, dealing with agents and publishers, and so on. Such books will often start with such basics as the rival merits of pens, typewriters and word processors. Others, like this book, may have a more restricted but still fairly broad theme, and others again may be devoted to a detailed look at, for example, historical novels, or short stories for women's magazines, or problems of grammar, spelling and punctuation.

What is true about how-to books on writing in respect of the range of approaches is true of how-to books on any other craft or hobby. The key to writing a good how-to book is to offer practical, common-sense advice which the reader can follow, and if you can suggest ways of achieving success without hard work you will be on to a winner – *Perfect Decorating Without Washing Down the Walls* or *A Guaranteed Way to Make Money Without Lifting a Finger* are sure-fire bestsellers (note the reassuring words 'perfect' and 'guaranteed'), but of course the books have to deliver.

Many books about crafts or hobbies are published in series, so would-be authors must in such cases not only check on what subjects have already been covered, but on the length and approach of a series for which they want to write.

Humorous Books
There is a big market for funny books, and almost every publisher is looking for a new humorous writer whose work will really make people laugh. The problem is that although all Britons, unlike any other race on earth, are gifted with the possession of an acute and unfailing sense of humour, unfortunately we don't all laugh at the same things. What makes you fall about may not raise the merest flicker of a smile on my face, and this is particularly

true of written humour, especially since it is neither fleeting, like a sit-com on the television, nor made comic by the extraordinary tones of a comedian like the late Frankie Howerd, but is sitting there in black and white on the page, unchanging, and challenging you to find it amusing. So it's quite a difficult field to break into, and many of the humorous books which are published consist of a collection of pieces or of cartoons by already established authors or artists, which have been previously printed in a newspaper or in a magazine like the late lamented *Punch*. However, as I say, new comic writers with the right kind of talent really can expect an enthusiastic welcome. So you send your hilarious material to a publisher, and it comes back, because the editor read it completely po-faced. What do you do? I think this is one instance where the reactions of your friends are worth having; in most cases, you cannot rely on the opinions of your nearest and dearest, or even of your slight acquaintances, because they are liable to be biased or to wish not to offend you. But it is very difficult for most people to fake genuine laughter, so if you are present when friends read your work and you actually see them unable to prevent themselves from laughing out loud with spontaneous amusement, then it is worth trying different publishers again and again until you find one whose sense of humour coincides with your own and that of your friends.

Of course, your book needs more than just an odd laugh or two – it has to be consistently funny and you must sustain the humour over a book-length work; equally, it must not be dependent on one joke only, repeated over and over again, and it should preferably have a certain amount of originality. The last point leads me to warn you not to try to write a funny book about your experiences in moving house. Almost everyone can tell you of hilarious experiences when moving house, but what happened to you is (a) not nearly as amusing as you may think, (b) exactly the same as happens to everyone else, and (c) not made any funnier by the extravagant over-writing and the liberal use of exclamation marks which almost always go with such books. On the whole, the writing of anecdotal

funny books should be avoided, unless you can do as well as Richard Gordon, James Herriot or Peter N. Walker (but preferably choosing other subjects than medical or veterinary practices or police work). As well as those consisting wholly of cartoons, the majority of humorous books are illustrated (partly in order to bump out a short text, and make the finished book look value for money), and if you can provide witty drawings of a suitably high standard to accompany your text, that will be a bonus. It is quite likely, however, that a publisher who accepts your book will commission an artist – usually a cartoonist – to provide the illustrations.

Law Books
Books on various aspects of the law are, naturally, written only by experts, even if they are intended for general consumption. If you are legally trained, then you may well be able to write something of interest. If it is for your peers, you will presumably know of any gaps in the books available which need to be filled, and you will be aware of the standard of work required. If you are writing for the public at large, on the other hand, you have great freedom of choice, and a gift for explaining complex things in simple terms could bring you considerable success. The niceties of the law are almost always totally incomprehensible to the man and woman in the street, who, if they come into contact with the law – whether as a result of committing a major or minor crime, or simply because they need to know how to make a will, or what their rights as householders are, or how to sue someone for libel – will often turn for help to any book which will explain what it is all about in terms that they can understand.

Literature, Books on
Literary establishment figures, dons and critics supply virtually all the published non-fiction books about Literature, and the fact that the largest numbers of such works are brought out by university presses testifies to the standards required.

Medical Books
Serious medical books intended for doctors (including

surgeons, psychiatrists and other specialists) and nurses, whether qualified or still at the student stage, have always had a ready market, and as techniques and understandings are constantly changing, new works in this area continue to appear. The range is wide, covering the treatment of every kind of disease, both physical and mental, and the books can be general in approach or restricted to one specific aspect of the subject. Clearly, only those who practise in the medical field in some form or other, and especially those who see the training of younger generations as part of their responsibility, are likely to write such books, and will probably do so only because they are aware of the inadequacy of what is already available on their particular speciality or because they have new information to convey.

Music Books
Almost all books about music, whether the subject is classical music, jazz or the various manifestations of pop, are written by experts. It would be possible, perhaps, for a non-specialist to write something like an account of the Promenade Concerts from their inception, or a catalogue raisonné of major brass bands, or a history of rock and roll, but even then a genuine interest and wide knowledge of the subject would be essential.

Nature Books
The depth of public interest in the natural world can be judged by the fact that TV programmes on nature subjects are to be seen every day of the week, and by the large membership of such organizations as the Royal Society for the Protection of Birds, the World Wildlife Fund and the National Trust (which is the most widely supported British charity, and which is as much concerned with the preservation of the countryside as with stately homes). If you have a special interest in some aspect of the natural world – animals, wild flowers, birds, the countryside, etc – whether your concern is with a tiny and familiar area such as your own garden (visited perhaps by badgers or by a remarkably intelligent robin), or with something more exotic like making friends with a family of lions, you can

be certain of a market for your book, provided that you have something fairly unusual and interesting to say (although you might just be able to get away with a content that is less than startling if your writing is of exceptional quality).

Television has accustomed us to brilliant camera work which, using the almost incredible variety of techniques now available, has brought the intimate secrets of wildlife in close-up into our living-rooms. This means that it is essential to be able to supply outstandingly good photographs to illustrate your work.

Pets, Books on
Manuals and histories of various breeds have been dealt with under 'Hobbies and Crafts'. There is also a special and continuing market for books which might be described as the biographies of particularly well-loved pets. Such books can be about a dog, a budgerigar, a pony, or even perhaps about a particularly attractive spider, but the most popular will be devoted to a cat or cats. The writing needs to be a little bit sentimental, with a smidgin of humour, and the animal should be either very beautiful, or a clown, or eccentric in its behaviour, or exceptionally faithful and even courageous. If you have had the right sort of pet and can write about it with love and sincerity, you may find it comparatively easy to get the book published, especially if you have some appealing photographs of the animal which could be included. More general books on household pets which are anecdotal or descriptive are also in demand. I should warn you, however, that although animal books are believed invariably to have great appeal, they don't always work – you need to get the mixture absolutely right.

Humorous books about pets are often successful, including those which pillory unappealing animals and their owners and which can be enjoyed not only by those who love cats and dogs (if they are prepared to laugh at themselves), but also by those who have no time at all for pets of any kind.

Photographs are needed for serious pet books, and cartoons for funny ones.

Philosophy Books
A surprisingly large number of books on philosophy is published each year. You can hardly expect to succeed in this genre unless you already have some pretensions to an established reputation in the field.

Photography Books
Books which come under this heading fall into two categories – they are either how-to books giving advice on the technique of photography (including, of course, video photography), in which case they really come under 'Hobbies and Crafts', or they are collections of photographs. The latter usually have a theme, which may be topographical, for instance, or could perhaps be based on studies of people belonging to a particular ethnic or working or regional group. If you are a really good photographer – an artist with the camera and a dab hand at the developing and printing processes which can enhance the quality of your work – and can put together a collection with an interesting theme, you have a good chance of finding a publisher. Collections which do not have some unifying motif of that sort are normally published only if they are the work of an established photographer with a considerable reputation.

Politics and World Affairs, Books on
This subject is likely to be the prerogative of politicians and political journalists. Certainly, extensive background knowledge is essential.

Reference Books
Reference books like dictionaries and encyclopaedias are usually compiled by teams of editors who are employed on a full-time basis by the publishers, and who will commission entries for encyclopaedias from recognized experts in the appropriate field. The term 'reference book' is, however, often used quite loosely to cover more general books which I hope to have included in this list under the relevant subject.

Religious Books
While theology is probably always the province of the priesthood, or at least of the academic, there are many opportunities for the laity, as well as for those who might be described as professionals, to write religious books of a more general nature, especially collections of prayers, anthologies, accounts of religious experiences and lives of saints. Unless writing on comparative religions, where a somewhat detached approach is likely to be necessary, you need to be fully committed to the religion about which or for which you are writing – any lack of commitment or insincerity is bound to show through – unless, of course, your book is intended to demonstrate the falseness of the religion which is its subject.

Scientific Books
Books on science are unlikely to be written by anyone other than practising scientists or by writers, such as journalists, who have specialized in writing about some aspect of science. This applies whether the books are highly technical, which will probably be strictly limited to one particular discipline, or are intended for the general public, in which case much wider subjects may be covered.

Sex Books
Many books nowadays are devoted to sexual techniques. It would seem to be necessary to be medically qualified before you can write such 'adult' books with any hope of publication, but perhaps if you have exceptional experience in the subject you might find a market for your work in this field.

Illustrations will almost certainly be required, in the form either of all-revealing colour photographs, if your publisher is bold, or of discreet drawings with no naughty bits, if there is a wish on his or her part to avoid any charge of publishing pornography.

Social Matters, Books on
Sociology is a very fashionable subject, but you cannot

really expect to succeed in that field unless you are fully qualified. On the other hand, books intended for the general public on less technical subjects, such as coping with bereavement, or poverty in the inner cities, might be acceptable from a well-informed writer despite a lack of formal qualifications.

Sports and Games, Books on
As a nation which is deeply interested in sport, it is not surprising that we produce large numbers of books on the subject every year, especially since the range of activities is so wide. Histories of a particular sport, biographies of outstanding exponents, reviews of the most recent season and, especially, books on how to improve your own game – these are always in demand. There are two criteria for writing about sport: one is to be a star performer, a coach or manager, or a sports journalist – in other words, you need to have a recognized position and a recognizable name; the other is to be a fanatical devotee of the sport in question, to have an encyclopaedic knowledge of it, and to dream up an original approach.

Photographic illustrations will be required.

Under this general heading I include also games, the most popular of which as subjects for books are chess and bridge. Don't think of writing about either unless you are an acknowledged expert.

Translations
Whether translations should be considered in a book about writing non-fiction is perhaps doubtful. However, despite the facts that much translation work is concerned with fiction and that all of it must be imaginative, it is perhaps worth including some advice, since would-be translators are unlikely to find help in many of the books about writing which are currently on the market.

Translators obviously need to be really fluent in the languages with which they are concerned and may also have to have some specialist knowledge if the books are at all technical (or familiarity with current slang in the case of contemporary fiction). And a translator must also be able to write good English which, while remaining faithful to

the original, does not sound like a translation, avoiding particularly any word-for-word renderings of foreign idioms or constructions.

Translations are almost invariably commissioned by publishers who have already bought English language rights in the book, and they will usually give the commissions to translators whom they know. There is therefore little point in translating a foreign book which you have come across, on spec, as it were, and then hoping to find a British publisher for it. It is probably better to try to get yourself established as a potential translator on the books of a number of publishers, which you might do by sending out details of your qualifications and perhaps specimen pages of your translation of some classic work. If you find an interesting foreign book which you would like to translate, you could then bring it to the notice of the publishers you have already contacted in the hope that one of them would consider that publication of an English translation was feasible, would negotiate purchase of the relevant rights from the foreign publisher, and would commission you to do the job.

Travel Books

Many would-be writers think that writing about travel must be one of the easiest things to do and that the chances of publication are very high. After all, the popularity of television travelogues points to a wide interest among the general public, and if you yourself have been lucky enough to go to some exotic part of the world, surely others will be interested in your experiences. There is certainly a large market for such books, but you really do need to have a special kind of eye, and to be a special kind of person, too. You will almost certainly travel alone, unless you are recording the events of an organized expedition or exploration of some kind. You will avoid tourist traps, and you will not be staying, except perhaps at the beginning and end of your journey, in comfortable modern hotels. You will probably speak the local language and will live as the locals do, sharing their meals and their often primitive homes, in small villages far removed from the bustle of the cities and from civilization as we know it.

In short, you will be exploring the *real* Patagonia or the *real* Laos or even the *real* Majorca (if there is any part of that island which is not totally given over to tourists). If you are the sort of person who enjoys this kind of travel, and especially if you have an acute eye for the curious, and the ability to convey the colour and strangeness of your observations, then you may have considerable success as a travel writer. It may mean that, although you can be friendly and outgoing enough to get along with the people you meet, in essence you are one of life's observers, standing back and watching everything around you. One thing you are not is self-obsessed, for although this kind of book is normally written in the first person singular, the 'I' of the account must not be obtrusive; your own actions and reactions in the circumstances that you are describing may be of great importance – and it is of course a *personal* account – but they must never overshadow too greatly the circumstances themselves.

A variation is the travel book which describes a particularly adventurous journey – cycling across the Sahara, perhaps, or rowing round Cape Horn or something of that sort which is part travel, part sport and part celebration of human determination, courage and endurance. If you are mad enough to undertake that kind of excursion, either alone or as part of an expedition, you will probably be able to sell a book about it – and you will deserve your success. You may even get a commission to write the book before you set out, with the usual proviso that the publisher will want to have some idea of whether you will be able to deliver an interesting and publishable book.

Even if you have not travelled farther afield than Majorca, you may think, when you consider the millions who visit the Balearics, that a book based on your stay there would undoubtedly be welcomed by those who are going to the island and want to know in advance what it is like, and who would like to have the book by them while they are there so that they get the most out of their holiday – while those who have been there already will enjoy reading it and comparing their memories with yours. Well, up to a point, Lord Copper (in other words, you are

wrong), in either case, unless you really do know everything that visitors might need to know, or which might conceivably interest them. For such a guide book you will have to liaise with all the local organizations not only in order to ensure that your information is correct, but also to check on future developments and changes, since your book must be as up-to-date as possible. You must also allow for the inevitable lapse of time while you write it and the publisher publishes it.

There is little chance of publication for a book which is in fact a diary of your package holiday in Majorca, even if it was a disaster from start to finish or if you managed to discover a bar which no tourist had ever visited before. If you insist on writing that kind of thing, restrict yourself to an article or two; even then, remember that you are not likely to sell anything called 'My Holiday in Majorca', while you might be more successful with something like 'How to Enjoy your Holiday in Majorca', consisting of useful advice based on your own experience, but without too many I's in it.

Travel books can also include books about the British Isles, varying from very personal accounts, for which you probably need a poet's eye and pen, to something approaching a guide book, which will usually have a special theme, such as an account of literary landmarks in some part of Britain, or perhaps of the village churches of Devon, or suggestions of possible walks in a given area. In all these cases, you need to know thoroughly what you write about.

It all boils down to this: if you have the essential expertise, which means, in the case of any kind of travel book, that you have travelled, that you have an observant, interested and inquiring attitude to everything you have seen, and that you write pretty well, then there is nothing to stop you entering this field, even if you have no existing fame or other qualifications.

The question of whether you will need illustrations for your travel book is an interesting one. Some of the most successful travel books of recent years, such as those by Colin Thubron and Paul Theroux, have carried no illustrations, while other travel books contain quite large

numbers of pictures, usually photographs taken by the author. You must make up your own mind, perhaps depending on your skill with a camera.

War Books
War is a subject of perennial human interest, and although we may not have had a global conflict for close on fifty years, the idea that we have been at peace for that period is ludicrous. Even if you consider only those wars in which the British have been engaged, we have had the Korean, Falklands and Gulf wars, not to mention the long-lasting and continuing fighting in Northern Ireland. And the rest of the world has not been idle in this field, even if the wars have been, on the whole, fairly small in scale. The reading public laps up books about war. In the 1950s and 60s there was a flood of personal accounts concerned with World War II, and naturally almost every top-ranking officer was able to write his story of how he won the war for the Allies. Such books are fairly rare nowadays, but if you should come across a wartime diary or a series of letters from someone who served in World War II (or, even better, World War I), then, if the material is interesting and you can knock it into shape, you may find a market for it. Otherwise, the only kind of book about past wars which is likely to succeed should really be called 'military history', and would be written by a historian or at least by someone who had made a really deep study of the particular war. The personal memoir may come into its own again in respect of more recent conflicts, and may be written either by journalists or by members of the armed services taking part (or, exceptionally, by civilians who get caught up in the fighting), and in those cases there may be a need to clear material with the military authorities before it can be published.

Women's Interests, Books on
I do not include under this heading such matters as you might find in most of the pages of a women's magazine. You will find those in the sections on 'Health' or 'Fashion and Beauty' or 'Cookery Books', or even perhaps 'Hobbies

and Crafts'. This paragraph is in fact concerned solely with the books which are currently published in considerable numbers about the position of women in society. Since the beginning of the women's lib movement such books have been very popular, and they continue to command a large market. If this is your interest, you stand a good chance of publication if you have something arresting to say on the subject, or if you wish to draw attention to a particular aspect of the problems which women face in today's world.

3 *How to Write the Book*

Who is Going to Read the Book?

The first decision to be made if you want to write a non-fiction book concerns the market at which it will be aimed – in other words, who is the potential reader of the book? Is it intended for beginners, or for experts? Will it appeal to the general public or only to specialists? You may say that you want to attract a very wide range of readers, and that your book will be suitable for people with varying levels of knowledge of the subject. That is fine, but the more clearly you can define your audience, the better, because it will probably make the book much easier to write, and possibly easier to publish.

Are there other factors to be considered? Supposing you are capable of writing on your subject at almost any level, from a book for the beginner to one for the complete expert – how do you decide which sector to aim at? It is worth bearing in mind that beginners always outnumber experts, so a book which deals with the basics of its subject will probably find a larger market than one aimed at specialists. On the other hand, there may be large numbers of excellent books for beginners already on the market, which might make it easier for you to break in if you were to write a more sophisticated book. If you are not aware of all the available titles which might prove competitive to yours, you will have to do some market research (which will come in handy anyway when you come to choose a potential publisher – see pp.101–2). Go to your local library and to any good bookshop and see what is on the shelves. It will also undoubtedly be worth

studying the library catalogues, which will list not only books which you don't see because they are out on loan, but also those on the subject which are kept in other branches. Buy or borrow all the competitive books, and study them to see what approach they take. (You may also find material in them which will be useful to you by adding to your own knowledge – but do read the warnings about plagiarism and permissions which follow on pp.87–91)

While you are doing this market research, in addition to checking on the amount and nature of the existing competition for the book you have in mind, look too for any gaps in the market. You may realize that there is no book on one particular angle of your subject, an aspect which you could tackle, even if you had not thought of doing so originally. But do make sure, whatever market research you do, to keep the reader firmly in mind. If you spot a gap, ask yourself who would read a book which would fill it. Perhaps the reason why no one has apparently written such a book is because there wouldn't be sufficient interest in it.

Tutors of creative writing often advise those who want to produce fiction to write firstly for themselves, so that their stories and novels are the kind that they themselves enjoy. To a large extent this is equally true of non-fiction, but it is nevertheless vitally important to aim at a specific market. Decide who your potential readers are, and then write for them.

Planning

Creative writing tutors are sharply divided about planning – some, like me, are fervently in favour, and others are equally vehemently against. However, this division of opinion is really in respect of imaginative writing, especially in relation to the novel, and I don't think anyone would disagree with the suggestion that planning is a necessity for non-fiction. Indeed, I cannot see how one could hope to write a successful non-fiction book without planning it first.

It might be claimed that this is not true in the case of

autobiography, where nothing needs to be planned because it has all happened, and you simply begin with your birth and work steadily through in an orderly, chronological fashion until you reach the present time. For that matter, the same might apply to a biography. But a moment's thought in the latter case will probably prove to you that you *will* need to create a plan. A life, as Shakespeare pointed out, is always divided into various ages, from mewling infant through to second childhood, but in many cases there will be far more changes to be taken into consideration than William S. suggested, with different schools, different jobs, different marital arrangements, and so on, as well as all the relationships with family, friends, colleagues and enemies; you will have to decide which aspects of your subject's life you are going to emphasize and which you are going to skate over, and therefore how much space you are going to devote to them – which periods of the life are going to be compressed into a single chapter and which will perhaps require several chapters. If you need to work out such matters for the story of someone else's life, it follows that you will almost certainly have to do the same for your own.

There are many advantages in having prepared a well-worked-out plan: it is a solid basis, a rock on which you can build a firmly structured book which will cover its subject thoroughly; it will enable you to see clearly the balance of your work, by which I mean the varying and contrasting amounts of attention that you give to different aspects of your subject; if you have planned carefully, and especially if you have taken plenty of time over it, thinking out all the details and noting them down, it will prevent you, when you come to write the book itself, from forgetting anything which you intended to include (which, in practice, is remarkably easy to do); it will allow you to see and list much of the information you will need to research; it will make it easier to get down to the actual writing, because you will always know what comes next – and it is particularly helpful in this respect if, for some reason, you have to abandon your writing for other activities for several days, perhaps, or even weeks; and, as

we shall see later in this book, a synopsis, which will be derived from your plan, will be vital when it comes to finding a publisher.

So how do you prepare a plan? In its simplest form it could be no more than a list of chapter titles.

How many chapters should there be? There are no rules. When planning this book, it seemed to me preferable to have a brief introductory chapter (see p.7) and then follow it with three wide-ranging, long chapters, rather than a whole series of mini-chapters, on the main aspects of a non-fiction book which I wanted to cover. A different approach might have produced ten or twenty chapters, or any other number you can think of. It is really a matter of deciding how much detail you are going to go into and how many words it will take you to cover the points that you want to make, and what the cosmetic effect (that is, the physical appearance of the book) will be, and how logical your divisions of the text are. The decisions are then up to you.

Returning to the preparation of a plan by making a list of chapters, if you were writing a book about, let us say, Pig-Sticking, you might produce something like this:

Chapter 1: Origins and History of the Sport.
Chapter 2: Rules.
Chapter 3: Terms of the Sport.
Chapter 4: Equipment.
Chapter 5: Training.
Chapter 6: The Hunt.
Chapter 7: Sticking Techniques.
Chapter 8: Modern Developments.

A list as brief as this doing duty as a plan will not help you a great deal. Something with much more detail is advisable, and it might be more helpful, once you have your list of chapters, to use a separate sheet of paper for each of them, and to jot down everything that you want to cover in that part of the book, starting perhaps with sub-headings, but also including little details which will illustrate the points you want to make. Some chapters may not need a whole page; in this imaginary book on

Pig-Sticking, Chapter 2 might consist simply of a reprint of the rules laid down by IPSA, the (equally imaginary) International Pig-Sticking Association; however, if the chapter is also to include the author's comments on the interpretation of certain rules, it will probably be worth making detailed notes.

It is unlikely that, at this stage, you will think of everything in the correct sequence in which the various subjects will be dealt with within the chapter, but that is of no consequence, because you can always sort it out later. My own sheets of paper (I use a ruled pad) are inclined to turn rapidly into a mess, with crossings-out and balloons and arrows all over the place, but I can usually go quite quickly, with a non-fiction book, from this chaos to an orderly breakdown of each chapter.

When putting things on paper, whether it is ruled or not, one tends to start a fresh line for each new idea, progressing steadily down the page. This is known to some tutors of creative writing as the linear approach. Some authors find it more stimulating to use the 'sunburst' technique, in which you place the title of the book in a circle, drawing rays out from it towards your chapter titles, and then further rays from the chapters towards sub-headings and from them to additional details. Because the rays do not have to be in any specific order, you may find it somehow easier than when using a linear technique to put all your ideas down as they occur to you, and to work out their correct order later.

A sunburst for the Pig-Sticking book might initially look something like the top diagram opposite:

Note that 'History' and 'Sticking techniques' have been circled, and there are no rays coming out of them. This is to indicate (and it could apply additionally to any other heading if the author felt so inclined) that the chapter needs a sunburst of its own, like the bottom one shown on the opposite page.

It does not matter at all whether you use the linear approach or the sunburst. My own preference is for the linear layout, but I know a number of published authors who always use sunbursts. The important thing is to get your ideas down on paper by whatever method. Don't

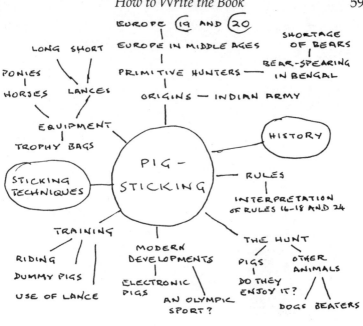

EUROPE (19 AND (20

EUROPE IN MIDDLE AGES

SHORTAGE OF BEARS

PRIMITIVE HUNTERS —— BEAR-SPEARING IN BENGAL

ORIGINS — INDIAN ARMY

LONG SHORT

PONIES

HORSES LANCES

EQUIPMENT

TROPHY BAGS

STICKING TECHNIQUES

HISTORY

PIG-STICKING

RULES

INTERPRETATION OF RULES 16-18 AND 24

TRAINING

RIDING

DUMMY PIGS

USE OF LANCE

MODERN DEVELOPMENTS

ELECTRONIC PIGS

AN OLYMPIC SPORT?

THE HUNT

PIGS

DO THEY ENJOY IT?

OTHER ANIMALS

DOGS BEATERS

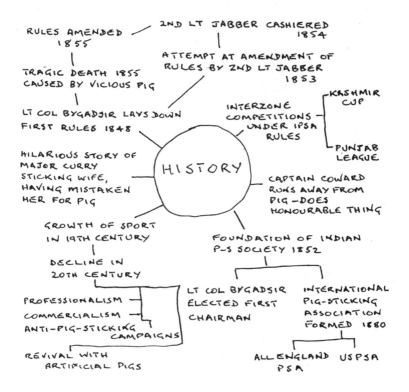

RULES AMENDED 1855

2ND LT JABBER CASHIERED 1854

ATTEMPT AT AMENDMENT OF RULES BY 2ND LT JABBER 1853

TRAGIC DEATH 1855 CAUSED BY VICIOUS PIG

LT COL BYGADJIR LAYS DOWN FIRST RULES 1848

INTERZONE COMPETITIONS — UNDER IPSA RULES

KASHMIR CUP

PUNJAB LEAGUE

HILARIOUS STORY OF MAJOR CURRY STICKING WIFE, HAVING MISTAKEN HER FOR PIG

HISTORY

CAPTAIN COWARD RUNS AWAY FROM PIG — DOES HONOURABLE THING

GROWTH OF SPORT IN 19TH CENTURY

DECLINE IN 20TH CENTURY

FOUNDATION OF INDIAN P-S SOCIETY 1852

PROFESSIONALISM

COMMERCIALISM

ANTI-PIG-STICKING CAMPAIGNS

LT COL BYGADSIR ELECTED FIRST CHAIRMAN

INTERNATIONAL PIG-STICKING ASSOCIATION FORMED 1880

REVIVAL WITH ARTIFICIAL PIGS

ALL ENGLAND USPSA PSA

worry about how trivial some of the ideas may seem – the more you put in the less you are likely to forget.

Once notes about the content of the book are down on paper, you need next to look at the organization of the book. Have all the items that you have listed been placed in the appropriate chapter? If everything which belongs together goes into one chapter, will that chapter seem too long in comparison with the others? If so, is it possible to split the material and make two or even three chapters of it, or is the disparity in the length not worth worrying about anyway? Should some chapters be amalgamated? In most cases, the answers to questions of this kind will probably seem fairly obvious, but although I think it is preferable to be absolutely certain about all such matters before you begin the actual writing, it is of course possible, if you are in doubt, to leave a decision until you have reached the stage of the final revision of your completed text.

You also need to decide on the order of your chapters, which isn't always as easy as it may seem. To take the example of the list for my Pig-Sticking book, should 'Rules' and 'Terms of the Sport' remain where they are as Chapters 2 and 3, or should they become appendices? Should 'Sticking Techniques' come before 'The Hunt', rather than after? Would it be more logical to put 'Modern Developments' immediately after 'Origins and History of the Sport'? With some of the books I have written I have agonized for ages over such questions, sometimes wondering how much it mattered, but usually feeling instinctively that it *is* important to get it right; and I have found that the best way of reaching a decision is to try to put myself in the place of the reader – if I were reading this book, how would I like it to be arranged?

This kind of organization is not confined to the order of the chapters, but is needed also within them. If, for example, you are writing a book like this and you come to a section dealing with the preparation of the typescript, you will probably begin with the layout of the pages, but at what point will you cover the question of word counts, and when will you give advice on the number of copies which should be made, and the quality of the materials

you use, and the permissible amount of hand-written corrections? You can work out such matters during the actual writing, and if you use a word processor it is easy to move blocks and indeed whole chapters, from one place to another. It is not so simple, however, if you are writing by hand or on a typewriter, and it is well worth it to organize the material beforehand, even if you do use a word processor.

To put all this another way, you need to look at the shape and balance of your book, and the shape and balance of the individual chapters. Shape is imparted by the logical ordering of the facts you want to present, with some sense of progression from each point to the next. To give a crude example, it would not have been logical nor would there have been any feeling of an orderly advance through the subject if the Pig-Sticking book were to start with the chapter on modern developments in the sport. The idea of balance is perhaps easier to understand – if I wrote twenty thousand words on pig-sticking terms and only two thousand on the more important subject of sticking techniques, I would have an unbalanced book. The same principles apply within chapters.

Planning is a great deal easier (not that it should ever be all that difficult for a non-fiction book) if you are writing a book which will form part of a publisher's series. For instance, the Pig-Sticking book might be part of a series of manuals on minor or forgotten sports, or you might be writing a book on, let us say, the Coreopsis as one of a number of gardening books all of which are produced in identical style and format. Not only are the already-published books in the series available to guide you, but the publisher may lay down quite strict lines for you to work to, specifying the subject of each chapter and the order in which it is to appear, so that the approach shall be reasonably uniform throughout the series.

A series may mean working to rigid parameters, but in other cases don't regard your plan as a strait-jacket. When you come to the actual writing, you may want to move away from it in some respect. Perhaps you have more, or less, to say on a particular subject than you expected, or perhaps a certain aspect would be more appropriately

placed in a different chapter from the one you had planned. It is *your* plan, and you can depart from it whenever you want to. But always think carefully about a change – your first instinctive idea may still be valid.

It is important to make it clear that the plan which we have been considering is written for *your* use only. It is the blueprint for your book from which you will work, and it is also in parts a notebook, but it is not necessarily the synopsis that you will show to a publisher. The synopsis (more about which will be found in Chapter 3 of this book) will probably be more polished and succinct, whereas your plan can be as rough and rambling as you like.

Title

It is not essential to have a title for your book at this stage, but you may by now have begun to think about what it might be called. You will certainly want to have a title when you come to submit the idea to a publisher, even if only so that he or she can change it (some publishers are prone to believe, curiously, that they are better than authors at choosing titles). What sort of title should you look for? Preferably something fairly short, and undoubtedly something which is descriptive of the book – on the whole it is considered better nowadays to leave the fancy, poetic, allusive title to fiction, and find something down-to-earth for non-fiction. Try to select a title which will attract the readers for whom the book was written.

Remember that there is no copyright in titles, so that if you have written a book similar to this one, you may call it *Non-fiction Books: A Writer's Guide* (though I hope you won't) without infringing my copyright. However, if you use the title of a book which is exceptionally well-known, its author would be able to sue you for 'passing off' – that is, for giving your book a title which might make a purchaser buy it in the belief that it was the famous one – so don't use *A Brief History of Time*, for example, even if that's what your book is.

Length

How do you decide how long your book should be? Beginners frequently ask this question, and it is almost impossible to answer in any more specific terms than by saying that it should be as long as it needs to be in order to cover fully, but without unnecessary waffle, all the points that you want to make. So it obviously depends on the complexity of the subject. It can also be affected very considerably by the audience at which you are aiming – if you are writing for the public at large, you may not go into the same amount of detail as if your readers are all expected to be expert; on the other hand you may need space to explain to the beginner matters of basic knowledge which it will not be necessary to include for the expert.

It may be advisable not to decide too rigidly on the length until you are commissioned to write the book, because the publisher is quite likely to have firm ideas about how long it should be. Publishers have to consider many factors in addition to the standard of the author's work and his or her qualifications for writing it, and among them are not only the size of the potential market, but also the length of the typescript. Very long books are very expensive to produce, which doesn't matter if the book is of such importance that a high price will not inhibit sales, but which may be a barrier if the work is of more modest pretensions; very short books, on the other hand, are not always as cheap to produce as you might think, and therefore sometimes demand a retail price which may appear to the general public to be excessively high. Since, for that sort of reason, a publisher is likely to ask for a particular length, is there any point in trying to work it out beforehand (assuming, that is, that you will be hoping to sell the book to a publisher on the basis of a synopsis and specimen chapters)? Yes, because if you approach publishers without any idea of the proposed length of your book, they are going to think that you are somewhat less than professional, and may suspect that, since you are apparently totally vague about how many words you will need to cover your material, the material

itself may be so amorphous in your mind that it won't be worth pursuing.

So you do need to work out the length, but it may be worthwhile, before you approach a publisher, to check whether there are sections of the book which you could omit or shorten if the publisher wants a shorter book, or equally extra material that could go in if a longer book is required. However, although it is almost always possible to shorten a piece of writing, don't ever agree to do so to the extent of losing clarity; to lengthen a book, on the other hand, you must find more substantive material to go in – mere padding always sticks out like a particularly unattractive sore thumb.

Nothing in the last few paragraphs gives much help to the beginner who has little idea of how many words it will take to cover a given aspect of the subject, let alone how long the whole book will be. As you write more and more, you become fairly practised at gauging the likely length of the chapters you have in mind, and you take this into account in the planning, asking yourself whether you have enough material to make a chapter or indeed a whole book, and if not what extra points you can legitimately bring in without resorting to padding. But without sufficient experience to work this out, I would suggest that you begin by writing one small section of your book, and see how many words it takes you to deal with it thoroughly; from that you should be able to extrapolate and reach a much better idea of what length the whole book will be. You do need, however, to be careful in making this kind of judgment – it is very easy to draw up a list of sub-headings for a chapter and to imagine that each of them will demand, let us say, seven hundred words, only to find that you can say all you have to say about several, or even all of them in a couple of dozen-word sentences. Avoid this trap by spending some time, while planning your book, in trying to work out how much or how little you will need to say on each of the points that you are going to cover.

Just as there are no rules about how many chapters a book should have, so there are none about the length of individual chapters, and all that can be said (not very

helpfully) is that you have to look at the proposed length of the book, and divide the total by the proposed number of chapters to get at the average chapter length required. (There is no point in doing this except as a kind of guide to yourself and a rough-and-ready means of measuring your progress as you write the book.) If your book is intended to be published in an existing series, you will presumably be working to a known overall length, and you can check the length of chapters which other authors writing in the series have used.

Style

A good style is essential for any kind of writing, but it is not, as many beginners seem to think, a natural gift granted to some and withheld from others. Good style does not demand that you should write like a poet, striving constantly for an extraordinary quality of vision, nor does it mean using high-flown language. Good style is above all a matter of writing with clarity and precision, allied to a sense of variety in the choice of words and in the rhythms of the prose. It is simple and it is unobtrusive.

If you feel that your style (or indeed any other aspect of your writing) is below par, how can you improve it? By reading and by writing. Read with analytical care the work of published authors, in order to see exactly how they do it (don't leave your critical faculties behind – not all published authors are good stylists). More importantly, practise your own writing as frequently and regularly as you can, and then try to stand back from it and look dispassionately at what you have written, so that you see its faults; read your work aloud (or, preferably, get someone else to read it to you), because the ear is a much better editor than the eye, and you will notice more things that need alteration (you might consider using the ear's discriminatory faculty *before* you put the words down on paper, by saying them aloud to yourself); look for the flow of your words, making sure that there is a variety in the length and structure of the sentences, correct any awkward phrases or obtrusive repetitions, and at the same time check that your meaning is always clear and that you

have included everything that needs saying without indulging in foggy waffling; think too about what I have already said (see p.61) about the need for shape and balance in the book and the chapters and try to apply the same principles to paragraphs and sentences; then rewrite and rewrite and rewrite to improve the quality of your work.

Apart from the possibility of altering the style in which you write for the better, whether you achieve brilliance or a merely adequate standard, your style is not going to be something immutable. It may be individual, but it can be altered to suit various circumstances: the approach can be formal for some purposes, and slangy for others; it can use simple, short sentences, largely without dependent clauses, and paragraphs consisting of two or three of those sentences only, if you are aiming at a punchy effect, or, if you are writing in what might be considered a more serious way, you can use a much more complex style, with long sentences containing dependent clauses, and sub-clauses and lengthy paragraphs, which will clearly make greater demands on the reader, although it is to be hoped that it will never lose its essential clarity.

The style you choose for your book depends partly on your own preferences, but the prime consideration, just as when thinking of the content, must be the market you are aiming at. If you are writing for those who read *The Sun*, you will use the technique of simple, short sentences and paragraphs, but for readers of *The Times* your prose can be more demanding, although you should probably vary the length and complexity of the sentences, and can also add occasional informalities such as 'don't' instead of 'do not', in order to lend variety to your prose. I also like to make much use of the words with Anglo-Saxon roots, which are often more direct, easier to understand and more effective than many-syllabled words of Latin descent – just think of the contrast between 'home' and 'domicile'. But again, it is advisable to use many of the available alternatives in this splendid language of ours, thus altering the flavour of what you write and adding spice to the style.

I think that it is important that a non-fiction book should, whenever possible, be entertaining as well as

informative, which is why I allow myself the occasional hint of humour (however feeble). I also feel that an author should not try to be too impersonal, and for this reason I sometimes put in an anecdote about myself, or express personal opinions even if I know that some readers will think them somewhat eccentric. A personal approach may sometimes work well too if you use your own experiences to illustrate some aspect of your subject, and this is especially true of how-to books, when you can perhaps reveal your own solution to a particular problem, or confess to some weakness and give details of your struggle to overcome it.

While it is a good thing to put something of yourself into the book, you should always avoid self-indulgence. Sometimes it is difficult to recognize where you are failing in this respect, but if you find yourself mounting a hobby-horse, or realize that you are saying the same thing again and again, then beware, because it may sound very self-indulgent to the reader.

Clarity is essential not only in style but also in the actual material covered in the text. You should try never to leave your reader in any doubt as to your meaning. If you are not an expert cook and are using a cookery book which tells you to cook something 'in a little water', you will know how infuriating such imprecise instructions can be – how much water is 'a little water'? a tablespoonful? a cupful? half a pint? (And for that matter, exactly how much is a cupful?) Make sure, too, not only that the instructions are clear, but that you don't ask your reader to do anything beyond his or her capabilities. A perfect example of the right approach is that which was used by Stanley Doubtfire when he wrote and illustrated a book called *Make Your Own Classical Guitar*, which aimed precisely to give the instructions suggested by the title; having written the book, before submitting it to a publisher, Stanley made himself a classical guitar, starting from scratch, and although he had made guitars previously, this time he did so following his own instructions to the letter, in order to make sure that everything was clear and possible, and that every necessary detail had been included. In the same way, you

should generally never assume that your reader has the same knowledge as you, except perhaps for the basics if you are writing a book which is designed for people who have progressed beyond the beginner stage. It may be irritating to some readers if you explain things which they know perfectly well, but on the whole this is to be preferred to leaving other readers with little idea of what you are talking about.

Research

Since you will be writing about a subject which you know well – you may indeed be an expert in it – you may feel that you will have little need to do any research. In fact, however completely your material already exists in your mind, needing only to be organized into book form and set down on paper, you are likely, at the very least, to need to check certain facts. Alternatively, research may be a vital part of the work, taking far more time and effort than the writing of the text.

Research is much more enjoyable and certainly easier than you may think. To begin with, virtually all human knowledge is to be found somewhere in a book. If you are interested in a particular subject you will probably already have acquired quite a library of books about it, and you may also have a store of articles and other items taken from newspapers and magazines (carefully filed, so that you can find them when you want them). Much of this material will need to be re-read, but it will all be there for you to refer to as you write. There may, however, be other books that you will need to consult. We are particularly fortunate in this country in having the best library system in the world, and librarians, whose expertise lies in the retrieval of knowledge, will be pleased to find for you any books that you want, and that applies whether they work in public libraries or other institutions.

In addition to the books in libraries, there are county archives and record offices, museums and other institutions where information is available, and many churches still preserve ancient records. Moreover, you should not underestimate the willingness of other human beings to

disclose information which they have, especially if you are 'an author', a job-description which to many non-writers somewhat inexplicably denotes a glamorous person. Suppose, for instance, that you are writing a biography of someone who suffered from an obscure disease; you can find out a lot about it in books, but those immediately available can't always answer your detailed questions; go to a doctor, and he or she will probably be willing to divulge a vast amount of information about that disease, looking up facts for you and, if his or her memory and reference books fail, telling you where else to go to get further details.

Research must be taken very seriously, because anything which you put in your book must be accurate, and this means that you should always double-check any facts which you learn in the course of your research. Dig as deeply as you can – even if you meet the same information in a number of books, it is possible that the earliest of their authors made a mistake which the others have copied. Write whenever possible from personal experience, rather than relying on second-hand information, and if you are writing a historical survey of some subject, always go back, if you can, to the original documents and sources.

For a contemporary subject which is constantly changing and developing, you will have to ensure that any information you gain from research is up-to-date, but if you are yourself an expert you should have no difficulty in this respect. If you are in doubt, seek advice.

The photo-copying machine is a great help to researchers. There are some legal restrictions on what you may or may not photocopy, and these are of vital importance to all authors. Without the laws on photocopying, huge amounts of copyright material could be reproduced by anyone without permission or payment of any kind. Generally speaking, you are allowed to make a single photocopy of an article or one or two pages from a book without the need to obtain authority to do so and without having to pay for the privilege, provided that the photocopy is for your own personal use, and not for resale.

An extremely helpful book is *Research for Writers* by Ann Hoffmann, who was herself for many years a professional researcher. Many authors find it well worth while to employ such professionals, because of the time that it can save them.

Some of your research may be wide in scope – you might need to bone up on two or three decades of European history – or you may be looking for single facts, such as the date when those large white £5 notes went out of circulation. Organize your research at an early stage (you often have the opportunity of doing this while planning the book) by making yourself a list of everything that you need to find out, and then work your way steadily through it.

The more of your research you can do before you actually start to write, the better. However, it is not essential to have completed it, especially if there is some item of information which you cannot easily find – you can start writing with the material that you *have* researched, while still looking for the elusive fragment, leaving that part of your book until later. Many authors find that research continues all through the writing of a book, and indeed into the revision period after the first draft has been finished.

Research, if it involves travel, the purchase of books, extensive correspondence and other costly items, can be extremely expensive. If you succeed in getting a commission to write a book, it is possible (but unlikely) that your publisher will agree to subsidize the research to a limited extent. However, there are other sources of money to help with research for worthwhile projects. The Arts Council of Great Britain awards a number of fairly substantial annual bursaries, but these are normally restricted to already published authors working on a new book. The Regional Arts Authorities (addresses are given on pp.139-40) offer more hope to the first-time writer, and although their grants are on a modest scale, they do much to encourage and help local authors. Very occasionally they will offer a small subsidy to a publisher to persuade the firm to take on a worthwhile but potentially uneconomic book, but are more inclined to make their

grants to authors rather than publishers. The Authors' Foundation exists entirely to provide grants for specific projects which have been commissioned by a British publisher, and the Kathleen Blundell Trust gives awards to published authors under 40 to help with their next book (both these funds are administered by the Society of Authors). In very rare cases a local newspaper or a business concern will be prepared to help an author, provided of course that the resultant book has some particular relevance for the paper or the firm. If you are engaged on a book which is going to cost you a lot to research properly, it is worth exploring the possibility of getting a subsidy from any channel such as those already mentioned, or from any others which may occur to you. They can only say 'no', and they might say 'yes'.

Writing the Book

The actual method of writing, whether you use a pencil, pen, typewriter or word processor, is entirely up to you – use whichever you like best. If you write in longhand, the work will have to be typed or processed eventually, and if you can't do it yourself, there are many competent typists who advertise regularly in magazines for writers. As for when you should write, choose the times which you find most suitable – you may be most fluent early in the morning or in the middle of the night, or you may, of course, be restricted by other work – but do write regularly.

When you know what you are going to write about, chapter by chapter, and indeed have broken down each chapter into its component parts, and if you know what market you are aiming at, and you have completed most of your research, then you are probably ready to begin writing. I say 'probably' because you may still need time to think everything through. Inexperienced writers often have a tendency to start putting the words of their text on paper at far too early a stage. Writing is thinking as well as actually writing, and the longer you spend in preparatory thought, the less likely you are to go wrong when you do commit yourself to paper.

You will naturally try to present your material in a consistent way, always aiming at the same potential reader, always preserving a logical, methodical approach. However, consistency is also necessary in what may seem to be much less important matters, and advance thought about them will pay dividends in the professional touch which your typescript will have. You should use a consistent layout for your typescript, and it certainly helps if you can make rules for yourself, and follow them strictly while writing the book, about how you will treat headings, how you will indent your paragraphs, and so on. You should also always use the same spelling and the same form for those words which can legitimately appear in different styles – for instance, it is entirely acceptable to write either 'bestseller' or 'best-seller' (or even 'best seller'), but one form only should be used throughout the book. The same applies to words for which a capital letter is possible but not obligatory – for example, are you going to refer to 'the king' or to 'the King'? I find it helpful to make a note, when I first use such a word in a book, of the style I am going to use, and I can thereafter refer to the note and make sure that I remain consistent.

You can write your book in any order that you like. If it is autobiography or biography or history, it will probably seem natural to begin at the beginning and progress through the story that you are telling in a chronological fashion. On the other hand, if it is a book like this one, you could write almost any section in isolation, though you might have to do a bit of tidying-up work at a later stage to make sure that the flow continued without interruption and that there were no references which did not tie together – and there might be other problems. I wrote *Putting on a Play*, an instructional book about amateur drama, in this bit-by-bit fashion, fitting all the sections together at a later stage, but it was an awful fiddle and demanded a lot of rewriting, and for all my other books I have begun with the first chapter and continued methodically through to the last one, even if occasionally I revert to something I have written earlier in order to insert a new piece of some kind.

It really doesn't matter which method you adopt. The

one essential is to keep going. The more regularly you can write, the easier it will be. You also need to keep going simply because there is no other way to finish the book – stamina is an essential quality for a writer – and you must go on despite the reluctance which you may sometimes feel. Most authors I have spoken to agree that at some point in the writing of a book, whether fiction or non-fiction, they become weary of it – possibly a little bored – and begin to wonder whether anyone will be interested in what they have to say, and whether it is worth continuing. The answer is simply to plod on, and it is instructive to discover that it is usually impossible for any outsider to guess afterwards where this crisis of confidence occurred during the writing, because the author's boredom has not transferred itself to the actual writing – or if it has, has been eliminated during revision of the book.

When I first became a professional writer I read John Braine's *Writing a Novel*. It contained, I thought, some excellent advice and some first-class nonsense, and in the latter category I placed his instruction to the writer to count the number of words written each day. I soon changed my mind, and now always record at the end of each day how many words I have achieved, and how much of the book I have so far written. I find it doubly beneficial. In the first place, I use yesterday's figure as a spur for today: if I wrote 1,000 words yesterday, I must try to improve on that today, or if yesterday produced 5,000 words (about my limit in a day), then I must try to write at least as much today. It may sound childish, but it works for me.

The second reason for keeping count is the far more down-to-earth one of measuring progress both towards the total number of words that the finished book should contain and the deadline for completion. Even with considerable experience, I can't always predict accurately how long a given section will be, so I find it helpful to check what I have actually written against my plan, which will give some indication of whether I am running short or writing at too great a length. As for the timing, even if your book has not been commissioned, so that you are not

tied to a date for delivery of the completed typescript, it is a good idea to set yourself a firm target for the book's completion, especially if you are one of those writers who find that without a deadline natural laziness will win the day – the daily word count should encourage you to keep to your schedule. You may also, by the way, find it helpful to prescribe for yourself a weekly goal of so many thousand words, which should be a realistic figure, neither so high that you have no hope of reaching it, and become discouraged, nor so low that it does not act in any way as a spur.

Collaboration

The most obvious form of collaboration in authorship is the ghost-written autobiography (see pp.32–5), but it can be a very effective method of writing other kinds of non-fiction books. Collaboration does not suit all authors, but writing is a lonely business, and the truth of that statement is not diminished by the fact that it has become a cliché. If you find that you can work with another writer, you will obviously avoid some of that loneliness, you may get much pleasure from it, and you will almost certainly stimulate each other, which is probably the greatest value of collaboration.

Although in many cases one collaborator has the requisite specialist knowledge and the other the writing skills, it can also work extremely well with collaborators who are competent in both fields – indeed, they may produce a better book in tandem than either could have written alone. The method of working will vary from case to case – the joint authors might sit in the same room, or stay miles apart, communicating through the telephone or the mail; they might hammer everything out together word by word, or one might write and the other criticize, or each might write different chapters according to their own specialities. As with so many other aspects of writing, there is no right way and no wrong way, there are no rules, and you do whatever works for you.

The one problem, of course, is to find your collaborator. You must choose someone who shares your interest in the

subject, and preferably someone whose ideas and abilities you respect, but this may not be too difficult since you will probably belong to a society or group where you might meet the right person. If you make a well-received approach to a potential collaborator, it will be vital to decide at the outset not only how you are going to work, but how any moneys which you earn together shall be split, which of your names will come first, and all such matters as that, and of course these important details should be clearly spelt out in any contract that you both sign for the publication of your work. It is also worth trying to set out some kind of procedure to deal with disagreements you may have in the course of writing the book, and neither partner should be afraid to break up the collaboration if it does not work satisfactorily.

Revision

If there is one thing that separates the professional writer from the amateur (apart, of course, from the fact of being published regularly), it is revision. Professional authors revise – amateurs all too often don't. Since few of us are so brilliant as to get everything right the first time we put it on paper, it is foolish not to revise. Moreover, the advent of the word processor has made revision so much easier that there really is no excuse for not tackling it. (Incidentally, a useful tip for w.p. users is to make one or more copies on disc of anything that you intend to revise, as well as back-ups of finished work; I sometimes make a hash of my rewriting at the revision stage, and it is much easier to retain the good bits of the new version and incorporate them into the original text if I have a separate file with the first version on it.)

Here are some suggestions of how you should set about your revision:

Put your work away for as long as you can bear without re-reading it. The idea of this advice is that when you do look at it again, you will come to it with fresher eyes than otherwise, and this will help you to be objective in your assessment.

Some authors like to revise as they go along, polishing

each paragraph or section or chapter as soon as it is written, others may decide to devote the last part of their working day to the revision of what they have written that day, and others again may prefer to get the whole book down in draft before looking it over. All authors have different methods, and since there are no rules about writing, they are free to adopt whatever procedure suits them best. However, even if you have revised meticu- lously as you went along, it will be essential, when the book has been completed, to read it again as a whole. I have already suggested that when seeking to improve your style you should read aloud what you have written, or have it read to you, and this is good advice also when you have completed your book and embark on revision.

As you read, be as self-critical as possible – examine the text word by word. Make sure that your prose is straightforward, that the words you have chosen do the job that you intended for them, and that you have introduced a satisfactory amount of variety in the words themselves and in the rhythms of the sentences. Check to see that you have not indulged in errors of syntax, and that your paragraphs are logically constructed, so that they consist generally of a group of sentences all of which are focused on one theme. Look at the way you have developed your argument or set down the information that you are giving, and check that it all follows on smoothly, one paragraph leading to the next. You also need to see that your style is reasonably consistent throughout and suitable for the market at which you are aiming, and that you have also been consistent in spelling and punctuation. Watch for tired, cliché-ridden writing, and keep a particularly sharp eye open for anything which is not clear or which unjustifiably assumes a knowledge that the reader may not have. Rewrite when necessary.

Much of this advice is the same as that given above in the section on Style (see pp.65–8), but it will have a more direct purpose when it is applied not only to the way you have written, but also to the content.

Most of us tend to over-write, rather than under-write, so you must also be prepared for the need to cut. Be ruthless. Every single word of your book should be there

for an identifiable purpose – which doesn't mean that you should reduce the whole thing to cable-ese, because the purpose of many of the words will be to make your prose readable and smooth in its flow. Nevertheless, you should cut anything and everything which doesn't need to be there – odd words, phrases, sentences, paragraphs, whole pages. You may have explained the same thing twice and in exactly the same words, or have used the same word five times in the course of a couple of sentences. Perhaps you have allowed yourself to include some self-indulgent personal references or anecdotes which will add nothing to the reader's understanding or enjoyment. And keep a look out for your 'habit words' – the favourite words or phrases that most of us use far too often (I always have to go through my work and take out 'of course' and 'obviously' all over the place).

Of course (there I go again!), you may have put in some of the things I have mentioned in the last two paragraphs quite deliberately, and there is no reason why they shouldn't stay if they are there for a valid purpose. Moreover, you should not allow yourself to become obsessive about these faults – just make sure that they are eliminated whenever they are obtrusive.

When you have completed your revision, do it again – and probably again after that. I like to go through a typescript four times, and that includes once when I read every word aloud and once when I go through the whole thing non-stop in a single day (the other readings may take many days) to make sure that I have been consistent throughout and have not failed to eliminate any unwanted repetitions. Although opinions on this subject differ, many authors thoroughly enjoy the revision process, finding it much easier than the actual writing; if you are among them you must beware of falling into the trap of perpetual revision. Some writers are so obsessed with polishing their texts that they can never decide that the work is complete and ready to be submitted to a publisher. I could myself be tempted to go on beyond my four revisions (like most authors, I am never entirely satisfied with what I have written), but I draw the line there, and I would suggest that in almost all cases a similar restraint

would be adequate – especially as your publisher may ask
you to make yet other changes.

Introduction or Foreword

Many writers find that an introduction or foreword allows
them to explain how they came to write their book, why
they chose the particular approach which has been used,
and perhaps to thank those who have helped them. There
may also be a need to include a statement similar to one
which appears in some of my own books to the effect that
the views expressed are mine alone, and not necessarily
those of my publisher or of the publishing firms for which
I worked in the past.

There is a temptation to allow yourself to run on in a
foreword. Resist it. Many of your readers will skip it
anyway, especially if it looks lengthy, so keep it down to
essentials. (The tendency that readers have to ignore
Introductions and move straight on to the main text is the
reason why the first, very short section of this book is
called 'Chapter 1' rather than 'Introduction'. I hope you
were fooled into reading it.)

An introduction or foreword written by a well-known
person who has some claim to authority in the sphere of
your book is always worth having. If you know such a
person who would be willing to write an introduction, get
permission to mention it to any publisher to whom you
send the work, but don't ask the celebrity actually to write
the piece until your book is accepted for publication. In
any case, he or she will no doubt want to read the
completed typescript before producing a commendatory
paragraph or two. And be warned – some famous and
wealthy luminaries, even though they are personal
friends, will expect payment (which is fair really, since you
are trading on their professional expertise and position).

Illustrations

Illustrations form an important, and sometimes essential,
part of a great many non-fiction books, and indeed in
some cases are the entire *raison d'être* of the work, the text

being of comparatively minor significance. Illustrations can consist of photographs, paintings and drawings, maps, diagrams, graphs, etc, and all of these can be in black and white or colour.

Although in certain cases, by arrangement between the author and publisher, the latter may be responsible for finding the illustrative material (often true of children's books and humorous books, an artist being commissioned by the publisher to supply illustrations or cartoons for an author's text), the onus is usually on the author to provide any necessary pictures, or at least to suggest the subjects and where they may be obtained. If you are writing, for instance, a biography of Henry VIII, you are hardly likely to have any personal snaps of the old boy, and you will have to rely on portraits and prints of the period. For more contemporary subjects, the photographic agencies (listed in the *Writers' and Artists' Yearbook*) are another major source of illustrations. Their collections include not only thousands of photographs of famous people and notable events, but also pictures covering everything else imaginable. Permission to use any illustrative material must be sought from their owners or the galleries where they hang, and fees will have to be paid (see pp.87–91).

If you intend to use copyright illustrations, it will help to have a list of possible pictures attached to the finished typescript or to a synopsis.

It is clearly a great advantage for the author to be a photographer or artist and to supply the relevant pictures or drawings, not only because they will be appropriate for the book, but because a publisher is likely to look more favourably on a book the illustrations for which are free of expensive permission fees. But let me emphasize again the necessity of being absolutely certain that your photography or your drawing is up to good professional standards. All publishers will tell you that when a typescript accompanied by illustrations is submitted for their consideration, it amounts almost to a rule that if the text is reasonably good, the pix will be execrable, and vice versa – but it is usually the illustrations which are the worse of the two. It's an exaggeration, but there's some truth in it. Reproduction in print brings out all the faults,

so your snapshot is of little use if it is at all blurred or out of focus or under- or over-exposed, and the wobbly lines on your diagram will look even more wobbly on the page of the finished book. You also need to remember the likely size of the published book and to be aware of the effect that reduction in size may have – the main features of your map of the Ruritanian capital may still be clearly visible when it has been reduced from a width of 24 inches to 8 inches (sideways on the page in the book), but all those small letters for the names of little side-roads, just big enough to be legible on the original, are going to need a powerful magnifying-glass to be read in the reproduction.

In the case of diagrams, and especially maps, do make sure that everything is consistent with the text of the book – it is remarkably easy, even if you have prepared the artwork yourself, to use different spellings for the place names on the map of a foreign country, for instance, or to use one term exclusively in describing a part of a machine in the text, and to label the part in a diagram with an alternative term.

Whether or not you supply the illustrations yourself, it will undoubtedly be helpful, if they are to be integrated with the text rather than appearing in a separate section, to indicate in the typescript where they should be placed, and if in a children's book the pictures are to play a major part, it will be necessary to produce a page-by-page layout, showing exactly how the text and the illustrations should appear.

The question of illustrations should be discussed as fully as possible with the publisher once your book is accepted for publication. The publisher will almost certainly want to have control of the number and type of illustrations – especially with regard to the use of colour, which substantially increases the manufacturing costs – and may have useful suggestions to make about the suitability of available material, sources, and the obtaining of permissions.

Your publisher will also advise you whether it will be better in the case of colour photographs (and sometimes even artwork) for you to supply prints or transparencies. If the pix are your own, you probably have both, but if you

are going to an outside source, it will be helpful to know which to ask for. In most cases, transparencies seem to be preferred.

Footnotes

Footnotes are regarded with disfavour by most publishers, because they add very considerably to the cost of setting the book in print, and this is true even in the present era of computerized type-setting. If you insist on having footnotes, you must be prepared for them to be placed all together at the end of the relevant chapter or, more likely, at the end of the book. This usually makes their inclusion possible without forcing the publisher to an unacceptable increase in the retail price of the book, but has the disadvantage of being extremely tiresome for the reader.

If the footnotes consist of acknowledgments of the sources for quotations within your text, it is difficult to see how to avoid their use, but although the scholar may want to check every such reference, the general reader may be less concerned and not particularly bothered by having them lumped together at the end of the book. It may be worth including a note at the beginning of the book in such cases to say that the footnotes refer only to quotations taken from works by other authors.

Many footnotes, however, are what might be called 'side comments' – little snippets of extra information which do not perhaps belong in the main argument of the paragraph concerned, but which have a degree of relevance to whatever issue it may be. The advice here must be to eliminate the footnotes wherever possible, and although this may sound like a rather philistine approach, and another example of how modern commercialism undermines good old-fashioned standards, in fact it is surprisingly easy to cut them out. If you examine your proposed footnotes you will probably find that all, or nearly all, of them can be divided into two groups: those which contain fairly important information, and those which are of peripheral interest only; in most cases, with a little ingenuity the former can be incorporated into the main body of the text, and the latter can simply be cut

without much loss; if you are left with a few instances which refuse to be incorporated or cut and which insist on remaining as footnotes, at least you will have cut down on the number.

If there are no more than a few footnotes in your book, you will probably be able to get away with having them on the relevant page, putting an asterisk or an obelisk in the text at the appropriate place. If you have a great many footnotes, you will have to use what are known as 'superior' figures (word processors sometimes refer to 'superscript'), and you will have to decide whether they should be numbered from 1 through to the end of the book, or whether you will begin with 1 again for each chapter. Your publisher will probably advise on this point.

Appendix

An appendix or any number of appendices at the end of a book can accommodate information, very often in the form of lists, which is relevant to the subject but which cannot be incorporated in the main text. One dictionary definition suggests that the material in an appendix should have some contributory value, but should not be essential to the completeness of the book. That may be valid for the appendix in this book, but would not be true in the case, for instance, of a list of past champions to be included in *A History of Pig-Sticking*, which would be incomplete without such important information. Don't use an appendix if the material can be included in the main text, but if it can't easily be fitted in, don't overlook the usefulness of this device, which can substantially enhance the value of your book to the reader.

Bibliography

It is not essential to include a bibliography, and for some books, such as autobiographies, it may be quite inappropriate. In many cases, however, a bibliography will be expected. It normally appears at the end of the book, before the index, and is a kind of appendix, consisting of a list of books and other sources either which

the author has consulted or which are recommended for further reading, or a combination of both. It is likely that the more serious and comprehensive your book is, the more widely you have researched and therefore the longer and more definitive the bibliography will be. Such a list is both important and impressive in establishing your credentials as an authority on the subject. A bibliography which consists of recommended reading (and may appear under that heading) will be less a record of the author's industry than guidance to the reader who wants more information on the subject or some aspect of it.

When you prepare your bibliography, make sure that you record the title of the books in the list, or the provenance of other material, with accuracy. Each book's title should be followed by its author's name, and that of the publisher and the date of first publication and that of any revised editions. In some cases, it will be important to include details of publication in the United States or in foreign language countries, depending mostly on whether or not your book will also be published outside Britain.

Index

An index will almost certainly be needed for a non-fiction book, unless the book is arranged in alphabetical order like a dictionary or in a few cases where the arrangement is so simple and the subjects covered are so self-evident that the contents page will be sufficient guide to anyone wanting to find specific information. In most cases, however, it has to be regarded as an essential part of the book, the usefulness of which will be greatly diminished if an index has been omitted.

Should you provide your own index or employ someone else to compile it? Most publishers' contracts for non-fiction books contain a clause saying something to the effect of 'if in the opinion of the Publisher and the Author an index is required, but the Author does not wish to undertake the task, the Publisher shall engage a competent indexer to do so'. This clearly suggests that it is the norm for authors to prepare their own indexes, but, as the Society of Indexers will tell you, few authors are

capable of doing the job properly. Well, they *would* say that, wouldn't they? Members of the Society of Indexers are qualified practitioners of indexing and they are professionals – and professionals in any field are always dismissive of amateurs. But of course they are right. Indexing is extremely difficult and demands a high degree of skill. Moreover, as Bernard Levin says (if I may single out one of the many bees that buzz about in his bonnet), it is 'an appalling and prolonged labour'.

If your book is long and complex you will be well advised to go to a member of the Society for the preparation of your index – if your publisher arranges it, he or she will almost certainly choose someone from the Society's list, which indicates, incidentally, those indexers who have specialist skills in certain spheres (such as biology or theology, to give just two examples). You can then be sure that you will have a competent index which adheres to the principles of good indexing and is suited in its comprehensibility to the nature of the book. However, I would strongly advise you to check the professionally prepared index before it goes to the printer – even members of the Society of Indexers can and do make mistakes, not only because of human error, but because they may not know certain aspects of the subject of your book sufficiently intimately to avoid them (and I am referring here not to the specialist book which has been indexed by one of the Society's specialists, but to something of more general interest which may cover an extremely wide field of information).

If you go to a professional indexer, you will have to foot a fairly substantial bill. This is not to suggest that professional indexers make unreasonable charges – indeed, they are poorly paid for the arduous and meticulous work in which they are engaged. Neverthel-ess, the amount may seem pretty enormous to an author who has received (as so many do) an advance which is the equivalent of a car worker's monthly pay for a work which has taken three years or more to write. Some publishers may agree to share the cost of the index with the author, which will make the charge a great deal less burdensome, but it is clearly important in those cases, if the publisher

commissions the indexer, to establish in advance just what your share of the cost will amount to.

If you decide to do your own indexing, there are some things to do and others to avoid.

In the first place, you must try to put yourself in the mind of users of the index, so that they will find the entries they want under the headings that they will expect. I have compiled indexes for a number of my own books, and having made some foolish mistakes in them, have been severely, and somewhat gleefully, taken to task by the Society of Indexers for these errors – mostly, but not always, with justification. And I have to say that I have learned a great deal and am therefore grateful to them, even if their comments were a bit on the acid side. But one of the nonsenses which they did not point out (perhaps because there were so many others) was an entry in one index under 'Do's and don't's in style'; I can't imagine that any reader would think of looking for such an entry at all, but if it was to appear it should surely have been as a sub-heading under 'Style' in the 'S' section of the index, rather than under 'Do's' in the 'D' section.

Avoid having too many page references under one heading – as a rough rule of thumb, six page numbers for one entry should be a maximum. Use sub-headings to break the references into more manageable quantities – for example, in the index for a book on writing there might be a large number of references to 'typescript'; those which deal with the delivery of the typescript, or its preparation, instead of being listed simply under 'typescript' could go under 'typescript, delivery of' or 'typescript, preparation of'. The first of these entries should also appear under the cross reference, 'delivery of typescript', 'delivery' being a key word which the reader is quite likely to look up; 'preparation', on the other hand, has less strength of this kind, and while it would not be wrong to give 'preparation of typescript' its own cross reference entry, it could be dispensed with.

If you have two entries for the same subject – e.g. 'typescript, delivery of' and 'delivery of typescript', then the main entry under 'typescript, delivery of' should have all the relevant page references, and the entry under

'delivery of typescript' should either have all the same page numbers or a note saying '*see* typescript, delivery of'. Don't ever commit the awful crime of instructing a reader who looks up, for example, 'delivery of typescript' to '*see* typescript, delivery of' and then allowing him to find there '*see* delivery of typescript'.

There is a temptation to index all proper names, but it isn't always necessary. For instance, I think that Mr Bernard Levin will forgive me (and the Society of Indexers will not blame me) if I do not add his name to the index of this book despite the reference to him a couple of pages back. It is a question of the importance of the entry, and of the kind of book we are considering – most proper names in a biography or history will be included, because the people concerned have an importance in relation to the main subject.

There are many other matters to be taken into consideration when preparing an index, and you will find that *Book Indexing* by M.D. Anderson is a reliable guide.

As for the actual method of compiling an index, it is probably best to use cards and a box file with alphabetical dividers. Read through your book, stopping to enter each subject and the relevant page numbers on a separate card, not forgetting cross references. Keep the cards in alphabetical order. When you have completed that work, you must decide on the layout and punctuation of the index, and how you will arrange the various entries in respect of headings and sub-headings. Again, you will find *Book Indexing* helpful.

The preparation of an index is a long, laborious business and should not be hurried, especially if you are not used to the work. Professional indexers, incidentally, are often under considerable time pressure, because they normally compile an index from the proofs of the book, and the publishers are always in a hurry to have the completed work in their hands. It is a very good idea, if you are indexing your own book, to do so on the typescript – it is a comparatively simple matter to change the page references when the proofs arrive.

Plagiarism

Research is a matter of gathering information which you can use in writing your own book, but it does not mean finding passages from other people's books which you simply copy into your own text without permission and without any acknowledgement of the source – that is plagiarism. Although some joker suggested that to consult and use one book would be plagiarism, while to consult and use two would count as research, in fact it is legitimate to acquire information from books written by other people and to repeat it, just so long as you don't pinch the authors' ideas or use their exact words without acknowledgement, pretending that they are your own original work. And, as already explained (see p.38), you should be very careful about using facts which are to be found only in the work of a single contemporary author and which could therefore be considered as his or her exclusive copyright.

There is no problem with generally accepted facts. You can use them without hesitation, but they should always be expressed in your own words and in your own style. Avoid following the same sentence structure, the same layout of paragraphs of any of your source material, or the presentation of the same information in the same order, because even if you have used different words, the copying may be very obvious. It is really a matter of common sense. Don't pinch other writers' ideas or work. Don't even 'borrow' from them. 'Borrow' in this context is simply a euphemism for 'steal'.

Permissions

The main point about plagiarism is that those guilty of it copy someone else's work *without acknowledging that it is not original to them*. The situation is different if you intend to quote in your book any copyright material without any dishonest pretence about its origin. Incidentally, it is a good idea, in my view, to quote other people if they have said or written something which is relevant to your point. A quotation may provide support for your own opinions,

or may be the starting point for a vigorous attack that you want to make on the quoted statement, but whatever use you make of it, it lends a certain variety to your material. Besides, it shows that you have done sufficient research on your subject to know at least what others have said.

If you do quote from someone else's work, it is not enough to name the author and the book from which the material comes – you will need permission to use the quoted words. That applies even after the author's death, for copyright usually remains in force for fifty years after the death of the creator of the work. Unpublished material is also copyright – copyright exists in anything written by you or anyone else as soon as it is written (this includes letters, the copyright of which belongs to the writer rather than the recipient) – so if you intend to quote from someone's unpublished material, you still have to obtain permission to do so. This also applies if the extract come from a work which is out of print, even if the publisher has ceased trading and has gone out of existence, and even if the author is foreign, whether or not the work has been published in Britain. Works created by someone who has been dead for more than fifty years are normally out of copyright, and you do not need permission to quote from them. However, you should always check the situation, because in a few cases (if the work was published posthumously for the first time or in a substantially altered edition), it may prove to be in copyright.

Although copyright normally belongs to the author (or artist, or composer, or other creator of the work), you will usually have to apply for this permission, in the case of text, to the original publisher of the work, though in some cases your request may be handled by the author in person or by someone acting on his or her behalf. The publisher normally has a licence to handle permissions, granted by the author in the contract, and has a specific interest because the relevant clause will lay down the share of any permission fees which the publisher may retain. So even if you are a friend of the author and have been given free permission to quote from his or her work, you will still have to clear it with the publisher.

You are, however, allowed to use short extracts from

copyright works without permission under an arrangement known as 'Fair Dealing'. According to the Copyright Act of 1988, the short passages must be used only for the purposes of criticism or review, but this is sometimes taken to extend to quotations used to illustrate your line of argument (whether you are agreeing or disagreeing with the quoted words). But the extract should not exceed 400 words, or, if you take a series of quotes from the same source, not more than 800 words in total (and in that case each extract should not exceed 300 words); if the quoted work is poetry, it should not consist of more than a quarter of the whole poem, and in any case of not more than 40 lines. (The figures quoted here are those which have been agreed by the Society of Authors and the Publishers Association, and although they do not have the force of law, they are generally accepted.) Because the Copyright Act gives free use of short passages only for the purposes of criticism or review, you must not take it for granted that you may include any extracts which are used simply to illustrate your argument – indeed, it is wise to clear any use whatsoever – but unless you exceed the wordage quote above, you are unlikely to have to pay a fee. In all instances, you should acknowledge the source of the quotation, giving the name of the author, the publisher, and the name of the work from which it is taken. Fair dealing does not extend to anthologies, for which all quoted material must be cleared, however brief it may be.

Similar conditions apply to illustrations and artwork, with the one difference that while a commissioned author, who is a freelance rather than an employee of the commissioning company, usually retains copyright in the work, the person or company commissioning a photograph or a piece of artwork (for instance, for the jacket of a book) often owns the copyright – but you should always check carefully to discover exactly what the situation is. Photographs frequently belong to the newspaper or magazine which employs the photographer, and a further possibility is that copyright will be vested in a photographic agency. The copyright in the photograph of himself or herself which an author commissions and then passes to his publisher for publicity purposes would

normally belong to the author, because the photographer is employed by the author to produce the photograph, but the photographer, if particularly eminent and well-known, may be able to claim copyright on the grounds of having contributed artistic quality to the photograph; even if the photographer is an amateur and your friend, it would be a courtesy to ensure that, whenever possible, a credit is given if the photograph is reproduced.

In almost all cases, other than the short extracts mentioned above, you will have to pay a fee for the use of copyright material, and you will often also be asked to supply copies of the book when it is published. Before attempting to obtain permission, you should find out from your publisher for exactly which territories you should get clearance – there is no point in buying world rights if your book will be published only in the British market. You should also indicate to the copyright holder what sort of use you intend to make of the material – that is to say, what kind of book you are writing, whether you are quoting the material within your own text or whether you are compiling an anthology, and who is going to publish it. And that last phrase leads to an important point, which is that you do not need to obtain and pay for permission until a publisher has agreed to publish your book, and indeed you may not have to pay any fee until publication of your work takes place (but, as with so many other things, it is important to make certain of this point – some copyright owners ask for payment as soon as they reply to your permission-seeking letter).

On the other hand, it is advisable to enquire about the possible charges at an early stage, because you may have to abandon plans to quote this or that if permission is refused, or because the expense turns out to be too great. You will probably have to pay very heavily for the use of artwork by an internationally famous artist, and you may be surprised to find when you apply to a gallery for permission to use an old master that there will be a substantial fee, despite the fact that the artist has been dead for centuries and you would have thought that the picture would be out of copyright.

Permission fees are never cheap – the charges for the

use of the lyrics for pop music are ludicrously high – but you will sometimes find that the fees are negotiable and you may be able to beat the copyright owner down, but this usually applies only if you can demonstrate that your book will have a particularly restricted sale, or possibly because its profits or royalties, or some part of them, will be donated to charity. Another possibility is that your own publisher may be willing to contribute to the cost of obtaining permissions, so it is important to discuss the matter at the time of signing a contract (the extent of the contribution will probably depend on a number of factors including your mutual relationship, and the nature of the book, but may also be affected if you are a member of the Society of Authors or the Writers' Guild of Great Britain and if your publisher has signed a Minimum Terms Agreement with those two organizations).

It is usual to make acknowledgment in the preliminary pages of the book of any permission given for the use of copyright material, in the form which the copyright owner requires.

Libel

The most important thing to recognize about libel is that of all the words you write only those which are damaging to a person's reputation, or which expose him or her to hatred, ridicule or contempt, are libellous. Furthermore, you cannot libel the dead – unless you write something which will reflect deleteriously on their descendants, so that the descendants themselves are libelled. You can therefore write anything at all about a living person provided that it is not offensive in any way (but do remember how quick people sometimes are to take offence at something not intended to be in the least critical). In theory you can be as offensive as you like if what you write is true, and you can prove that it is, because proven truth is not libellous, but you must recognize, firstly, how difficult it often is to prove the truth of opinions and beliefs, and secondly, that it will almost certainly prove far outside your pocket to do so if the matter comes to trial.

You can also defend what may seem to be libellous material on the grounds of 'fair comment', which is the justification that journalists and others use when they write in uncomplimentary terms about politicians and other people in the public eye, but you will still have to show that the comment is a matter of opinion, rather than fact, and that you wrote in good faith and without malice.

Other defences are that of 'privilege', which applies mainly to reports of judicial or parliamentary proceedings, and that of 'innocence', which is invoked principally by authors of fiction, who try to prove that they did not intend to libel the person concerned and did so accidentally.

Libel is always to be avoided. It is potentially extremely damaging for the publisher of your book, for its printer, and especially for you, since it could not only land you with an enormous bill for damages and legal expenses, but could also end your career as a writer. Tell your publisher if your book contains anything which you think may be libellous, and don't be surprised if he or she asks you alter it, especially after taking legal advice on the matter. Of course, it could be that the publisher will not be worried, and that you both intend to go ahead for a number of possible reasons: you may be sure that you can prove the truth of your statements without difficulty; you may consider it a matter of public duty to expose what you believe to be the wickedness of whoever it is; or you may be relying on the idea that your victim would not sue because it wouldn't be worthwhile (because of the unwelcome publicity which would ensue, or because you haven't enough money to pay up even if the case goes against you, or for some other reason – a fairly dodgy concept, because the libelled person might be only too pleased to prove you wrong).

Obscenity, Blasphemous Libel, Sedition and other Offensive Material

You might think that in the present permissive age, when censorship has virtually disappeared (at least in the free world), authors need hardly worry about any of these

'crimes'. However, there are still some things which are not permissible: 'obscenity' covers outright pornography; 'blasphemous libel' ('blasphemy', in lay terms), while legally applicable in this country only to Christianity, is in fact likely to be invoked in the case of many other religions; it is under the heading of 'sedition' that Governments prevent the publication of their secrets; and 'offensive material' includes the legal offence of racism, and other prohibitions which are no less strong, despite not having been given the force of the law, such as sexism, classism, ageism, and any other -isms you may be able to think of.

Avoid all these, and don't be surprised if you are asked to remove from your book what may seem to you to be comparatively innocent material. Publishers are very much aware of the dangers, especially in these days of 'Political Correctness' – and remember, it may take only one complaint from one offended individual to involve you in crippling legal expense and the possible outcome of your book being banned.

4 How to Sell the Book

Presentation of the Typescript

Publishers expect that material submitted to them will be typed, always in double spacing (except for poetry and drama, for which there are different rules). It used to be accepted that extensive quotations from someone else's work would be typed in single spacing and to a narrower width than the rest of the book, but this approach is less favoured nowadays (if the publisher wants to have such quotations set in some distinctive style, the typescript can be marked accordingly before it is sent to the typesetter). The typing should be on one side of the paper only, and good margins should be left at the top and at the bottom and on both sides (1 inch or 25 mm all round is suitable). If your word processor has the facility to produce justified lines, don't use it, despite the nice appearance it gives, because it can make it more difficult for the publisher to calculate the length of the book accurately.

If your book has footnotes of the kind which will appear at the foot of the relevant page rather than lumped together at the end of the chapter or book, don't put them at the foot of the typescript page, but immediately after the line in which the asterisk or obelisk or superior figure appears, separating them from the main text by typing lines above and below the footnotes.

Illustrative material, whether photographs, artwork or diagrams of any kind should not be drawn on or pasted on to the pages of the typescript, but kept separate, with an indication on the back of the material (use a brush pen, especially with photographs, so that no unwanted

indentations are made on the illustration) of the page of the typescript to which it belongs – an identifying number or letter is helpful. Indicate on the typescript where the illustration is to appear – e.g. 'Diagram 17 here'. As with footnotes, it may be a good idea to separate this indication from the surrounding material by lines above and below it.

As already suggested in the previous chapter, you should try to be consistent throughout, and that advice applies to several matters: use the same margins on all pages; have the same number of lines on all full pages; stick to the same style of headings, sub-headings and any other divisions of the text (this applies not only to whether you put headings in capital letters or in upper and lower case letters, and whether they are to be in roman, italic, or bold roman or bold italic, or any other variation, but also to whether you centre the heading on the page or line it up on the left); don't vary the style of punctuation; standardize your spellings and your use, or non-use, of hyphens, capital letters, etc.

The final typescript should also include the 'prelims' (that is, the preliminary pages which carry any necessary material before the main text begins).

The first page of the prelims in the printed book may be what is known as a 'half-title', which usually consists of the title of the book only (although the blurb is sometimes also printed on this page), but it is not necessary to include a half-title in the prelims of a typescript, and the first page will almost always be a titlepage, which should have the title of the book, the author's name or pseudonym, the real name and address of the author (or the name and address of the author's agent), an indication of how many words the typescript contains and details of the number of illustrations supplied or required.

It is not necessary to include a copyright notice on the titlepage, or anywhere else in your typescript. Your work is copyright as soon as you have written it, but there is no particular value in stating this until the book is published, when your publisher will include a copyright notice, normally consisting of the word 'copyright', the copyright symbol, the author's name and the year of publication – e.g.: Copyright © Joe Bloggs 1993. This notice normally

appears on the back or verso of the titlepage, known as the imprint or biblio page. As well as the copyright notice the publisher will arrange for it to carry the printing history of the book, the names and addresses of both the publisher and the printer, and certain other details, such as the ISBN (International Standard Book Number – a number which will identify the book world-wide). The imprint page may also include a declaration of the author's 'right of paternity' (see pp.97–8), if the publisher does not decide to place it elsewhere in the prelims – a decision which probably rests on the number of preliminary pages available.

Do not put 'First British Serial Rights' or 'F.B.S.R.' on the titlepage of a typescript that you are offering to a book publisher. Serial rights, whether first or second, British or overseas, are what you sell to a magazine or newspaper, whereas a book publisher will wish to purchase 'volume rights', but will take it for granted that this is what you are offering, without any need for the words to appear on your titlepage.

To calculate the word count which appears on the titlepage, you do not have to count every single word in your typescript; nor should you use your word processor's word-counting facility. Instead, proceed as follows: count the number of words in ten consecutive full lines on five different pages of the typescript; divide the total by 50 to arrive at the average number of words per line (the result may be a figure which runs to two places of decimals); count the number of lines on a full page (this should be the same figure for each full page, but if you have not been consistent in this respect, then take the average of, say, ten full pages); multiply the average number of words in a line by the number of lines on a full page to arrive at an average number of words per page; multiply this last figure by the number of pages in your typescript, excluding the titlepage, list of contents, and other similar preliminary material; round the answer up or down to the nearest thousand. Note that this method intentionally takes no account of short lines, nor of short pages at the beginning or end of chapters. It does, however, produce the figure that publishers want to

know. (It has been assumed in the above instructions that, as is desirable, you have used the same typewriter or the same style of type on your word processor throughout – if you have changed, do try to ensure that the actual size of the type is the same, because otherwise you will have to make different calculations for the different type sizes in order to complete your word count.)

After the titlepage will come the rest of the prelims, consisting of some or all of the following: a list of the author's previous books, a list of contents, a list of illustrations, acknowledgments for permission to use copyright material or for assistance in the writing of the book, a declaration of the author's moral rights (see below), a dedication, a foreword or introduction.

You will not be able to put page numbers on the lists of contents and illustrations at this stage – there is no point in putting the relevant page numbers from the typescript, because they will almost certainly change when the book is set up in type, but you could use zeros to indicate that the correct figures will be supplied later. The chapters may have titles – in non-fiction books they usually do – but in some cases, especially if you are not going to have an index it may be helpful to supplement them with details of what the chapters contain, perhaps using your sub-headings for this purpose, as for example:

3. HOW TO SELL THE BOOK 00
Presentation of the Typescript — Desktop Publishing — Finding a Publisher — Packagers — Sponsored Books — Subsidized Books — Submissions — Synopses and Specimen Chapters — Commissions — Rejections — Agents — Contracts — Self-Publishing — Copyright

The author's moral rights were established by the Copyright, Designs and Patents Act of 1988, and consist of 'the right of integrity' and 'the right of paternity'. The former protects the author against the distortion or mutilation of the work in any adaptation or treatment of it, and exists without the requirement of any statement of its existence. The latter guarantees that the author will be

identified in any use which is made of the work, whether as a whole or in part, and this right needs to be 'asserted' by the author in order to be effective; to assert it, the author must require the publisher to print a notice in the book, and this is normally done by including wording in the prelims of the typescript as follows:

The right of (Author's name) to be identified as the author of this work has been asserted by him (her) in accordance with the Copyright, Designs and Patents Act 1988.

The text of the typescript should be numbered consecutively from its first page to its last, not starting with '1' again with each new chapter. Some authors also put the title of the book, or a shortened version of it, alongside each page number, and although this is not essential, it is probably quite a good idea. The position of the page number is unimportant – it can be at the top of the page or at the bottom, on the left, on the right or in the centre. It is not necessary to number the pages of the prelims, but if you wish to do so it may be convenient to use small roman numerals.

Begin chapters on a fresh page. You don't have to start halfway down the page, but it is usual to drop down one or two lines from the top. Indent paragraphs a few spaces (two will do, and certainly not more than ten), and never leave blank lines between paragraphs, unless you intend to indicate a break in the text.

Use white A4 paper of reasonable quality for the top copy – 70 gsm (which means that the paper weighs 70 grammes per square metre) or heavier is suitable, though you can choose something lighter, if you wish, for other copies. If you have a word processor, you can use continuous paper (often called 'computer forms'), but make sure that it is plain rather than lined, and get the kind which has perforated edges with guiding holes for the feeding mechanism, removing these side strips before you send the book to a publisher. It may seem quite unnecessary to add that if you are using continuous stationery the pages should be separated, and not sent out in their 'concertina' form, but some authors (even if very

few of them) do need such elementary instruction.

Change your word processor or typewriter ribbon frequently, so that the letters are black rather than grey, and don't use your word processor's draft mode except for your own purposes – any copy which you expect someone else to read should be in high quality mode.

Although you should aim at presenting a perfect, clean typescript, corrections by hand are permissible – indeed, one of the reasons for using double spacing is that it leaves room for the insertion of any necessary alterations – but make sure that they are totally legible (it is a good idea to use separate letters in the style used by children in primary schools rather than 'joined-up' writing), and as soon as the page starts looking at all messy because of the number of corrections on it, re-type it.

You should make at least three copies of the typescript – the top one will go to the publisher, who, if the book is accepted will probably want the second copy, and you will need one for yourself. If you produce your work on a word processor it is simple to run off extra copies if they are required, but do keep your discs so that there is no problem in doing so (and it's wise to make duplicate discs too). If you are using a typewriter rather than a word processor, you could photocopy the top copy of the typescript, but this is fairly expensive and you may prefer to use carbons – but please change the carbons frequently, so that the results are not grey and fuzzy.

It is preferable not to fasten your typescript together with pins or paperclips, and if you use staples, one in the top lefthand corner is sufficient for each batch of pages. Above all, do not bind the typescript together, either in a ring binder, or with tapes through punched holes, or with spiral bindings, or in any other way which turns it into a solid lump which is heavy to hold – it's even worse if the pages don't open sufficiently to lie flat. Most publishers prefer a typescript to consist of loose single sheets kept together in the kind of box that typing paper comes in or in wallet-type folders.

Some publishers nowadays are willing to accept books on disc, but you should check first that they will indeed take them in that form, and that your discs will be

compatible with their machines. At the time of writing it is still true that the majority of publishers prefer submissions in the form known as 'hard copy' (that is, a print-out on paper), and the disc will be used only at a later stage when any necessary alterations or corrections have been made to the text and the final version of the book has been agreed. However, technological advances are so swift that submission in disc form may soon become standard.

Desktop Publishing

Desktop publishing (not to be confused with self-publishing, which is dealt with later) is a term which suggests a mini cottage industry, in which the author conducts the whole publishing process from the top of his or her own desk. In fact, it means little of the sort, and has more to do with the presentation of the author's work than anything else. Most books are printed nowadays by lithography, a process which involves photography of the pages and use of the resultant film. Desktop publishing is a method of bypassing the work, normally the publisher's responsibility, of getting the book set in type and preparing the layout, including the sizing and positioning of illustrations, before a book can be put before the camera. The desktop publisher, thanks to the facilities of word processors, is able to present the main publisher with 'camera-ready copy'.

Although it is possible to use the cheaper and less versatile word processors and their attached printers to produce this camera-ready copy, you are more likely to need fairly sophisticated equipment with the facility to print in a variety of styles and sizes, and even to use full colour. Desktop publishing has two major advantages. The first is that, since it is produced on a word processor, it is extremely easy to make alterations to the layout (so that by changing a word or two, for instance, a chunk of type can be made to fit the available space), and to experiment with possible layouts without having to paste the material into place and then unpaste it and put it somewhere else. Secondly, it allows authors to ensure that their books are designed in exactly the way they would

like. Moreover, since the process will save publishers time and trouble (and possibly money), they are often especially interested in submissions in this form. However, you do need to have suitable equipment and some knowledge of book production and design.

Finding a Publisher

· You can choose the publisher to whom you are going to submit your non-fiction book by opening the *Writers' and Artists' Yearbook* or *The Writer's Handbook* to the appropriate section, taking a pin and stabbing with your eyes shut. It is not a method to be recommended. Although a very large number of publishers bring out an extremely wide range of books, some are very restricted in their interests. Even the largest firms with the most extensive lists often never venture into certain areas – gardening books, perhaps, or religion, or sport – or they may be unsuitable for you because they are too up-market or too low-brow. Moreover, although you might find just the right firm for your new biography of Florence Nightingale – they publish historical biographies, their books are of the right sort of intellectual level, etc – they are not going to be interested if they have only just brought out a new book about that lady.

What you need to do instead is some market research, which means simply that you try to find out which publishers are likely to be interested in the kind of book you have written or propose to write. It is not difficult, and you may have already been able to make a start when researching material for the book itself.

Go to your local public library, and look for books on your subject. Study the contents, noting the length of the books, the number of illustrations, etc, and trying to judge the markets at which they are aimed. Check who the publishers of such books are. While you are there, have a talk with a librarian. Librarians are usually happy to help authors with advice as well as with their research (it makes a nice change from dealing with people who merely want to put their names down for the latest popular novel).

Go also to your local bookshop – preferably one which is not concerned with all sorts of commodities besides books – and talk, at a moment when the business is quiet, to the owner or manager, describing your book and asking advice as to which publisher might be interested in it. Ask too for information about competitive books – booksellers normally have access to microfiche listings of all books in print. Most people who have specialist knowledge are happy to share it with serious inquirers, and you will be very unlucky if the bookseller fails to give you worthwhile information.

At the library, or possibly at the bookshop, you may also find another most useful source of information of this kind in the shape of the bi-annual 'Spring and Autumn' numbers of *The Bookseller*, the principal organ of the publishing and bookselling trades. These huge issues consist principally of advertisement pages in which virtually all British publishers list the books which they intend to publish over the next few months. However, at the front of the magazine are a large number of text pages in which many of the books are briefly described, and these descriptions are arranged by subject. If you are writing, for instance, a book on computers or a manual on a minor sport, such as pig-sticking, you will find in these pages classified notes from a whole string of publishers who might be interested in those subjects. You may also discover whether there are any books about to be published which are directly competitive with yours, and the approach which such books have taken.

Armed with the results of your research, you should be able to make a list of publishers who would possibly be attracted by your book, starting with the best bets, either because their names have been suggested by a friendly librarian or bookseller or someone else with the right kind of knowledge, or because they really seem to be the ideal firms for what you have written. You may, of course, know someone who knows a publisher, or you may even yourself have an editor friend; if so, then by all means make use of any introduction that you can get, but don't expect special treatment – the belief that you can get published only if 'you know someone' isn't true, and

publishers, who are in business to make money, do not select books on the basis of friendship or influence. The longer your list, the better, because although you may be lucky and get a commission from the first publisher you approach, you are equally likely to have to try a great many firms before you strike gold.

You might think that there is a much easier way of finding a publisher – after all, every week you can see advertisements in respectable newspapers and magazines saying something like 'Authors Wanted' or 'Looking for a publisher? Send your book to us.' Beware. Such advertisements are likely to emanate from vanity publishers. Vanity publishing is a technical term, which does not apply to self-publishing, however vain the authors of self-published books may in some cases be. Vanity houses attract authors who cannot find regular publishers for their work, praising the submissions they receive and promising to publish them provided that the author will contribute a share towards the cost of production. The sums they require are always substantial, and, far from being a share, usually represent not only the entire cost of manufacture, but the vanity publishers' profit as well. They promise that the authors will rapidly recoup their money in the form of larger-than-normal royalties on sales of the book, but since booksellers recognize the vanity publishers' imprints, and normally do not stock their books, the sales never materialize, apart from the copies which the unfortunate author buys (usually royalty-free, unlike the practice in ordinary, commercial publishing). The vanity publishers then weep crocodile tears as they tell you that, alas, the promised royalties are not after all due, and all that the authors get is a few nicely produced copies of their books at the cost of a small fortune.

This very brief account of vanity publishing may give the impression that the people who run such firms are criminals, extorting money from gullible authors under false pretences. There is in fact nothing illegal about what they do. Although when you make the obligatory visit to their office they promise you the earth, orally, nothing will be put in writing that they cannot fulfil (or if anything is, it

will be so hedged around that no blame for failure can be attached to them). Their contracts are watertight legal documents which will give you no opportunity of suing them for non-fulfilment of any obligations, let alone the chance of getting any cash back. Only the authors who allow themselves to be conned in this way can be convicted of a crime, and what they are guilty of is criminal stupidity. If any publisher suggests that you should contribute to the manufacturing costs of your book (apart from asking for payment of a part or all of the expenses for permissions or for the preparation of an index), check with the Society of Authors or the Writers' Guild. It is possible that the firm in question is legitimate, but if you are told that you are dealing with a vanity publisher, run a mile. (See also the section on Subsidized Books on pp.107–8)

Packagers

Packagers are people who produce books for publishers to sell. The books are usually highly illustrated, with much colour, and the packager sells them to publishers in different countries and different languages all over the world, thus building up a large print order and making it feasible to include all the full-colour pix which would be too expensive for one publisher to produce on his own. The text, printed in black, can be easily changed for the different languages without affecting the reduced costs of the colour printing.

The ideas for these books are normally dreamed up by the packager, who will approach an author to write the text. At the earliest stage, the author will probably be asked to provide a small portion of the text only, and will not be commissioned to complete it until the packager has succeeded in interesting sufficient publishers in the book to make it economic to proceed. While the author then prepares the text, the packager's picture researchers gather together suitable illustrations, and sales efforts (to additional publishers, that is – not to booksellers) continue up to the time when the book has to go to press. The books are then manufactured, each edition with the appropriate

publisher's imprint, and delivered to each of the publishers, who have to pay at that stage for the entire print quantity which they have ordered at a price which includes the author's payment. The publishers are thereafter responsible for warehousing, publicizing and selling the book, but because they have already paid the packager in full, do not have to render royalty statements or advise anyone if the book is to be remaindered, although special arrangements may have to be made to cover such matters as the sale of subsidiary rights or legal problems.

The author is paid by the packager, sometimes in the form of an outright fee, but preferably on a royalty basis or with an arrangement which, after an initial fee, brings the author additional lump sums if the original print quantity is increased or if reprints are produced. The author's royalty is usually a considerably lower percentage than that which a regular publisher would pay, but the author benefits from being paid for the entire printing at the time of its delivery, rather than having to wait for royalties on actual sales.

This arrangement can be very attractive. So how do you get a commission from a packager? It is very difficult, unless you are already an established author and preferably one who is recognized in a certain field or genre. If a packager wants to produce a book which we will call *Gardens of the World*, for instance, he or she would probably approach someone like Dr Stefan Buczacki to write it, or would go to Colonel Archibald Purpleface (Indian Army, Retd) for *An Illustrated History of Pig-Sticking*, or might think of asking a novelist like James Clavell to write the non-fiction text for a highly illustrated book on the Far East. However, if you have a really good idea for a book which would be suitable for the use of illustrations on a lavish scale, and if it is on a subject which you can write about with authority, it may be worth your while to make an approach to a packager. Packagers are listed in special sections in the *Writers' and Artists' Yearbook* and *The Writer's Handbook*.

Sponsored Books

In the past, particularly in the eighteenth century, the money for the publication of books was sometimes raised by the author, who approached a number of wealthy potential patrons and persuaded them to pay for copies of the book in advance. The system was known as 'subscription' (a term still used in the publishing trade – when publishers solicit orders for their wares from booksellers, they 'subscribe' the books and these pre-publication orders are known as the 'subscription'). The nearest equivalent today of the eighteenth century book published by subscription is probably the sponsored book, usually initiated by a fairly large company which wants a book to be written to promote its products. The sponsor may want the book to be published by a regular commercial house or may, if it is an organization which perhaps owns a chain of retail outlets, handle the publication and distribution itself, selling the book to the general public. An example of this might be *The Pig-Sticking Handbook* published by a chain of sports shops which is also the manufacturer of pig-sticking equipment and will use the books to ram the excellence of their products down the throats of their readers, and to encourage them to ram those products into the poor pigs.

A commission to write a sponsored book is likely to be welcome to any authors who are not so preoccupied with their own ideas that they have no time to take on such a job. It is often very well paid. There should be good earnings from royalties, or if the firm insists on some form of outright fee, it will probably be a quite generous sum, which the company will be able to consider as a tax deductible expense. There are, however, some possible problems for the authors of such books. Firstly, there may be a need to do a very considerable amount of painstaking research; secondly, they will obviously have to toe the party line, as it were, concealing anything which is not to the credit of the firm, cracking up its products to a possibly undeserved extent, and trying all the while not to sound too sycophantic; and thirdly, and most importantly, the firm may propose employing them on a temporary

basis, while the book is being written, in order to ensure that the copyright shall be owned by the firm rather than the author (see p.133). This last possibility is to be resisted – authors should never surrender their copyright and should try hard to insist on being regarded as freelances, not employees. If you find yourself in this position and your protests are unavailing, which is quite likely to be the case, then at least make certain that you are very highly paid for giving up your copyright.

It must be obvious that you are not likely to be asked to write a sponsored book unless you are known to the sponsor, and in the case of a large national company you will probably need to be an already established writer. However, if you are thinking of writing a book which would lend itself to the frequent recommendation of a given firm's products, it might be worth approaching the concern and asking for sponsorship.

Subsidized Books

Many sponsored books are subsidized, but I am using the term here to apply only to books which are subsidized by the author, rather than by a firm, and which are not primarily intended to boost a product or the company which manufactures it. If you have a lot of spare cash which you would be willing to spend on getting your book published, but do not want to go to a vanity publisher, you might be able to find a legitimate firm to take it on with a subsidy from you. How is that different from vanity publishing? In two ways: firstly, a regular publisher will not accept your book unless it meets the firm's standards of what is publishable, however much you are prepared to pay, whereas the vanity publisher will accept any old rubbish; secondly, with the regular publisher, you will have a standard contract giving you a real chance of getting most or all of your money back. However, although there are quite a few wealthy would-be authors around, not many subsidized books get published, because even in hard times publishers prefer books to stand on their own feet. One form of subsidy from the author which may be more acceptable to the publisher

than a contribution to the manufacturing cost is a guarantee to buy a very substantial number of copies, which may be possible if you have the means of selling them to people or organizations which the publisher would not normally be able to reach.

Submissions

If you have completed your book, having done your market research, you can work your way down your list of possible publishers, sending it to each in turn, until you get an acceptance or decide to give up. However, this can be expensive, because of the postage costs, and it is sensible to write a letter of inquiry before sending out your typescript. Telephone the firm at the top of your list and find out the name of the editor who is likely to deal with the kind of book you have written. Check the spelling of the name, too, and if it is a woman find out whether she likes to be addressed as 'Ms', 'Miss' or 'Mrs'. Then write to that person, describing your book briefly (but at sufficient length to give an adequate idea of its content) and giving any information about the potential market or any endorsement which might enhance its prospects (again be brief and businesslike), and ask whether you may send it for consideration. You might also like to inquire, if you use a word processor, whether the firm would be prepared to consider a book submitted in the form of a disc, naming the word processing programme you use so that the publisher will know whether it is compatible with his or her equipment.

Generally speaking, publishers nowadays understand that you may wish to send your work simultaneously to other firms (assuming that you have more than one copy of the typescript available), which will probably save you a lot of time; most of them have no objection to the idea, but they do like to know about it, so you could say in the preliminary letter that you propose to follow this procedure. If one of your selected publishers objects, you have the option of sending your work initially to that one house only and waiting for their verdict before approaching any others, or of leaving that firm off your list

and going to those who do accept simultaneous submission.

If you want to offer the publisher a subsidy towards manufacturing costs, I rather doubt whether this is the time to do it, because it might put the editor off by suggesting that you have no confidence in your work or that you think the firm for which he or she works is in the vanity trade. Keep such a suggestion either until the book is accepted or you receive the kind of rejection which appears to express genuine regret on the grounds of the book having too small a market or being too expensive to produce. On the other hand, if you can subsidize the book by buying a large quantity for re-sale to special non-booktrade outlets, it will probably be worth mentioning in your inquiry letter.

Enclose a stamped addressed envelope when you write. If the answer expresses a willingness to consider the work for publication, then mail or deliver it to the publisher, with a covering letter and with postage for its return if it should prove unsuitable. Some authors also like to enclose a self-addressed and stamped postcard for an acknowledgment of receipt. If you deliver your work in person, don't ask for an interview or indeed expect to do anything more than hand it to a receptionist – editors aren't usually very keen on leaving what they are doing to come and talk to unknown authors, and in any case, your book should not need any explanation or additional information beyond that which can be conveyed in the covering letter.

How long do you have to wait for a reply after sending in a book? Publishers receive large numbers of submissions of various sorts, some of which are given priority, perhaps because they come from an agent or from an author who is already on the list, while others require considerable time to be spent on their consideration, so it often takes a long while for a synopsis or a completed typescript to work its way up from the bottom of the slushpile.

('Slushpile' is a term used in the trade for the stack of unsolicited material which can be found on every editor's desk – that is, material which does not come from either an agent, an overseas publisher or an established author.

'Slushpile' sounds like a pretty derogatory term, and it is, because the vast majority of the material in it is likely to be of poor quality and of little interest to the publisher; however, most sensible editors pay careful attention to the slushpile, since among the dross may be lurking a new bestseller, or at least a book or an idea which will repay careful consideration.)

If your book can rapidly be seen to be of no interest to the publisher, you may get a reasonably quick reply once the typescript gets to the top of the pile. But if it is not an immediate candidate for rejection you will probably have to wait much longer for a verdict. In many publishing houses, an assessment from more than one editor is required before any report back to the author will be made, and some books, especially if they are either on esoteric subjects or are very specialized in their approach, cannot be fully assessed within the publishing house, but have to be sent to specialist outside readers. Outside readers are not always noted for the speed of their reading and reporting, and although the mails are not as slow as some complainants say, an additional allowance has to be made for transit times. Even if all the reports on the project are good, the editor may still not be able to give the author the news before discussing the idea with his or her colleagues – notably the sales people.

For all these reasons, then, if you have submitted a completed book, you will probably not receive a verdict in under three to four weeks in the case of a rejection, and will wait perhaps twice as long if the book demands serious attention. If for some reason more time than that is needed, a good publisher will let the author know, explaining the delay and asking for patience. If you have heard nothing at all from the publisher after three months, it is time for you to write a gentle letter of inquiry; after six months without a word, you can send a vigorous demand for news; if the delay is longer than that, you will probably need a letter from a solicitor threatening legal action for the recovery of your material. Don't be afraid, by the way, of upsetting the publisher at that point; if your book has been kept for a very long period without the courtesy of any information at all about its progress, your impatience

may undermine the publisher's interest in you, but if the firm has been so slow in reacting it will probably be equally inefficient in other areas, and you will almost certainly be better off to try your luck elsewhere.

Synopses and Specimen Chapters

Authors of non-fiction books have a great advantage usually denied to novelists because it is often possible for them to be commissioned by a publisher to write a book on the basis of an approved synopsis, or to complete one which has been submitted in the form of a synopsis and specimen chapters. This way of working has been acceptable for many years for established writers, but within the last couple of decades has become quite normal for beginners too, although you will almost certainly have to provide the specimen chapters unless you have a good track record as a writer and your work is known to the publisher concerned. From the author's point of view, working in this way has two great merits: you don't need to spend a lot of time writing something which will never get published; and a commission is both an incentive and a great encouragement.

How do you prepare a synopsis for submission to a publisher? What should it include? How much detail should be given? How long should it be? In rare cases, either because the author is already well known to the publisher, or perhaps because of the nature of the subject, little more than a list of chapter titles may be required, but if you are a first-time author, or you have not previously written in the genre in question, the publisher will be less inclined to take anything on trust, and a full-scale synopsis will be required.

It should be written with care. When considering what it should contain, it is perhaps helpful to consider the job that it is supposed to do: a synopsis sets out to persuade the publisher that the book is one which his or her firm should publish, and that you are the right author for it, and no publisher can make that kind of judgment without being presented with sufficient relevant facts. So the synopsis must be reasonably detailed, summarizing the

contents in their entirety and without omitting anything of significance, and it must cover information about the market at which the book is aimed, and your qualifications for writing it. Its length will depend on the complexity of the book, but on the whole I would suggest that a fair extent, with the inclusion of a considerable amount of detail, is preferable to a brevity which does not describe the book adequately – the publisher really does want to know what its content will be. At the same time, however, beware of any tendency to start writing the actual book itself – you are presenting a summary, not the complete work or part of it. Equally, although a synopsis is a selling tool, designed to make the book attractive to a publisher, you should not confuse it with a blurb (the wording which will appear on the front flap of the jacket of a hardcover book or on the back cover or first page of a paperback): a blurb is intended to entice a member of the public into buying the book, which it may do by exaggeration of the book's merits, or by teasing suggestions or questions about what may be found in it – in short, it may have a considerable degree of inaccuracy, both in what it does say and in what it does not; a synopsis, on the other hand, should be truthful and comprehensive.

Although it is not essential to do so, it is probably sensible to begin the synopsis with a statement of the general purpose of the book, and this is where you should indicate the approach to be taken – is it to be a simple manual, or of a more complex nature? will it try to cover every aspect of its subject in some depth, or will it be restricted to one specialist area? is it intended to fit into an existing series? is it controversial and iconoclastic, or traditional and bland? And, above all, who is the reader that you have had in mind when writing the book?

This introductory paragraph will probably be followed by a list of the chapters, with details about their contents set out sufficiently fully for the editor to see how comprehensive the coverage will be. This material may be derived from the plan of the book which you prepared if you followed the recommendation in Chapter Two, but since it was suggested that the plan, being written for your own purposes, should include a great deal of detail, notes

to yourself, and so on, you will probably need to cut it and re-work it into a coherent summary. Continue with notes on any material which will follow the main text, such as appendices, bibliography and index, and also with information about the illustrations which will be required, if any, indicating whether or not you will be able to supply them yourself.

The synopsis should give an estimated length for the completed book, but you may also wish to intimate that the extent could be varied by the omission or addition of certain chapters (although I would be wary of such an approach, since it might seem to invalidate the presumed perfection of your original scheme).

The next paragraph is of vital importance. It should explain exactly why your book is worth publishing, and why the reader for whom it is intended will want to read it: because 'it fills a long-felt want', to use that old cliché, since there is no other similar book available, and perhaps never has been; because it is different from, and preferably better than, the books on the same subject which are currently in print; because the kind of reader at whom you have aimed it forms the major part of the market for such books; because it could be tied in to a forthcoming anniversary; because of anything else that you can think of which is in the book's favour. All this, again, needs to be spelt out in detail, and as factually as possible, with enthusiasm but avoiding any hint of over-sell.

You should find out what else is available in the same field, get hold of copies, and be able to list the books, point out where they differ from your own work, and indicate their failings, if any. You should also, if possible, know something about the likely demand for a book on the subject (be realistic), and if there are societies which will be interested in it, especially if you can obtain a mailing-list of their members, you should tell the publisher about that.

Don't cite the favourable comments of your friends or relations on your work, but if you think you can get, or already have the promise of, an introduction from someone who is an authority in your field, and preferably a household name into the bargain, this may help

considerably not only to establish your own credentials, but to arouse the interest of the publisher.

It is at this point too that you list your own qualifications for writing the book. This is not an occasion for blowing your own trumpet so loudly that it sounds quite unbelievable. At the same time you must not be by any means over-modest. You should list in a factual, dispassionate way not only your academic qualifications, and your membership of organizations which are relevant to the subject of your book (especially if you hold a prominent position within them), but also all the experience you have had either as an expert in the field or as a writer, or both. And, if you have not already made it clear, it is worth saying what drove you to write the book. You might also add a few words about the plans you have, if any, for other books in similar vein which you might write – on the whole, publishers look for authors whom they can establish with a number of books, rather than for one book by itself (although they will naturally accept a single offering if it has the right quality and appeal).

It is usually worth while to give an indication of how long it would take you to complete the book, if commissioned to do so, though this subject could be left for discussion at a later stage unless it is important that the book should be published in order to coincide with some forthcoming anniversary or other notable date (remember, by the way, that the normal delay between receipt of the author's final typescript and publication is nine months, so it will not be much use to give a delivery date which is only a few weeks before the event).

As already suggested, you can try to get a commission to write your book on the basis of the synopsis only, but, especially if you are an unknown author, it is probably advisable to add to your submission an indication of your writing ability in the form of specimen chapters.

Some would-be authors, especially if they have already completed the book, sometimes submit a synopsis accompanied by odd pages apparently extracted at random from the text. This is not to be recommended. Not only do single pages fail to give sufficient material on which to judge the work, but, although such authors

usually choose pages which they hope will impress, they rarely do.

It is preferable to submit whole chapters, and the usual practice is to supply at least two of these, and often three. The main purpose is to show first of all that you are literate (and it is surprising how many would-be authors are not), and then to give clear indications of your style and approach, the authority with which you write, and the degree to which the material has been organized and is comprehensive within the bounds which you have set yourself. It is usual to include the first chapter – the opening pages of any book are vital – and the editor will be looking at it in order to get an impression of the clarity and interest of your material, and to see whether you are writing in a way which will hook your readers and persuade them to go on reading. After the first chapter, you may simply continue with Chapters Two and Three, or you may take later parts of the book, especially if you want to demonstrate how you have coped with any difficulties that your selected chapters may have offered, in which case you may wish to explain this in the synopsis.

In fact, if you begin by submitting a synopsis only, and the publisher then asks to see specimen chapters, you are probably well on the way to getting a commission. Publishers can usually tell from even a brief synopsis (because they have considerable expertise in such matters) whether or not the author is likely to produce what they want, so the requested specimen chapters are often less of a complete test than a confirmation of what they already believe.

As for the presentation of your material, most of the advice given at the beginning of this chapter applies equally to synopses and specimen chapters. Some authors have the idea that while the chapters will be in the normal double spacing, a synopsis should be presented in single spacing. Well, it can be, but it will be much easier to read if you use double spacing, and publishers always like the work submitted to them to be easy to read. A few writers go to enormous trouble over the presentation, setting the titlepage up in Letraset or using fancy types from their

word processor, and trying to make the whole thing look like a glossy brochure from the world of popular entertainment. Some publishers may be impressed by this bezazz, while others may regard it as an over-sell. I believe that if the material is really good and is neatly and clearly set out, your book will attract a publisher even with a modest presentation, but an exception might be made if you are intending to go in for desktop work, in which case an elaborate presentation could be a legitimate part of your submission.

The few differences between a submission in the form of a synopsis, with or without specimen chapters, and that for a completed book are that you will not need a word count, you will probably number the specimen chapters starting each time from '1', you will not have to include any prelims, and if you use a titlepage it will include an indication that what you are presenting is a synopsis.

It is worth pointing out, by the way, that just as your own plan is not a straitjacket, you are not rigidly bound by the synopsis on which you have been commissioned to write a book. Of course you should stick to its basics, but if you find a better way of dealing with your subject or realize that you want to include more or different information, you should do so. Most publishers are aware that books develop and change and grow as they are written, so minor alterations are usually accepted without fuss – indeed, the publisher may not even be aware that you have departed from the synopsis. If the changes are more radical, you would have to consult your editor about them, but the chances are that no objection would be made, provided that you could put forward a convincing argument showing that the book's quality will be improved.

As for the procedure for submitting a synopsis to a publisher, it is similar in many ways to that for a completed book. However, you can probably dispense with the initial inquiry letter, although you should still find out who would be the right person to send your work to, and should still enclose postage for the response. The covering letter with your material might suggest that you would be glad to come to the publisher's office, if

required, to discuss the matter, and you would also be prepared to submit a specimen chapter or chapters. Because of the difference in length and the fact that you are trying to sell an idea rather than a completed book, publishers usually react much more quickly to a synopsis than to a full typescript, and you may therefore decide that it is hardly worth bothering with any attempt at simultaneous submission to a number of publishing houses; on the other hand, if you do want to send the synopsis simultaneously to more than one publisher, you should indicate that you are doing so.

Although the editor may need to do a little market research, and to discuss the idea with others in the firm, in general it would not be unreasonable to expect a reply within a month, and as soon as that length of time has passed without word, you could make a polite inquiry about the progress of the assessment. After three months without word, you should probably consider writing to say that you intend to withdraw your proposal.

It should be obvious that if you submit specimen chapters along with the synopsis you may have to wait a little longer for a verdict, but it is still likely to be a speedier process than that for a completed book.

Commissions

A commission to write a book may result from your submission of a synopsis and specimen chapters, but there is also the possibility of the initiative coming from the publisher. It is part of an editor's job to dream up ideas for saleable books, rather than simply waiting for them to be submitted out of the blue, and having thought of a possible subject, he or she may then approach a suitable author with an invitation to write the book. Such a book might form part of a series ('We need a book on Pig-Sticking for our Sports Guides'), or might be inspired by a news item ('Colonel Purpleface has just won the Olympic gold medal for Pig-Sticking, so let's get him to write a book'), or might be considered for all sorts of other reasons ('It will fill a long-felt want in Pig-Sticking circles', or 'I'm interested in Pig-Sticking, so I'm sure other people

will be', etc). Whatever the origins of the idea, by the time that the editor is ready to approach a potential author, he or she will almost certainly have a pretty firm and detailed concept of the book, and will go first to a writer who is likely to produce what is wanted. This will be an author who is personally known to, and who has probably already written books for, the editor, or one who, although published by another company, has established a major reputation for the kind of book that is envisaged, or one recommended by an agent whom the editor can trust to put forward only a suitable candidate. It is therefore extremely unlikely that an unknown will be commissioned in this way.

If you do receive an invitation to write a book for a publisher, you may be presented with a very tight brief to work to, or you may be given a considerable degree of freedom (although in that case you will almost certainly be asked to supply a synopsis for approval), or it may be a matter for several meetings and much correspondence before all the details about the content of the book are agreed. The important point to make is that the editor will almost invariably welcome suggestions from the author, except perhaps if the book is to be part of a very rigidly structured series, and will often accept them. The author must, however, be sensitive to the concept which the editor puts forward, and must be wary of trying to turn the whole idea upside-down.

The need to listen carefully to the editor is equally valid if the publisher decides to commission you to write a book which you have submitted either in completed form or as a synopsis and specimen chapters. The concept may be yours, but it will pay you to make any changes which the publisher suggests, provided that you can do so without offending your own integrity. If the suggestions are good ones, be prepared to say so, and accept them with alacrity. If you think the editor's ideas are stupid, at least consider them carefully, taking them more seriously than you may feel they deserve, and then discuss them with the editor at length in correspondence and, if possible, face to face, until you can get an acceptance of your point of view, or a suitable compromise is reached, or you decide to

withdraw from the project.

Rejections

Publishers reject books for many reasons, and among the most frequent are not believing in the existence of a large enough market (either because interest in the subject is limited, or because the book will be very expensive to produce and must carry a retail price which will seriously inhibit sales), not publishing books on that subject, not having any evidence that the author is capable of writing the book, and having recently published a book on the same subject (especially if it had a similar approach). There are other reasons, including, I suppose, the possibility that the well-known excuse given in rejection letters, 'our list is full', might actually be a true statement, rather than a polite way of saying 'we wouldn't touch your book with a barge-pole'. 'Not suited to our list' can also be a response to rubbish, but often means exactly what it says, and suggests that you haven't done your market research properly.

Even if you know with certainty that a huge market exists for your cheap-to-produce book, and that the publisher to whom you send it does indeed publish books in that field but has not brought out anything directly competitive (nor has – as you have discovered by telephone enquiries – anything similar in the pipe-line), and if you are convinced that your submitted work demonstrates your ability to write to an acceptable standard, you may, despite all this, receive a rejection. Indeed, it will be quite surprising if you do not. It is not easy to get a book published, and it has become much more difficult in the last twenty years or so. Publishers have a vast number of proposals submitted to them, so they are spoiled for choice, and it may take you several attempts before you end up not merely with the right publishing firm, but with an editor who is enthusiastic about your project.

The first rejection you get may seem like a body-blow, especially since it is quite likely to come in the barest fashion, without a word of explanation about why the

material has been rejected. A few publishers pride themselves on always trying to explain their reasons, however briefly, but the majority say that if they made a habit of advising rejected authors why their books have been turned down (let alone what they should do to improve them, which would be very desirable from the authors' point of view) they would then inevitably be drawn into discussing the matter in lengthy correspondence, and would never have time for the books which they *are* going to accept and publish.

So be prepared for that first cold, formal rejection. However devastated you may be, you must simply pick yourself up, dust yourself off and start all over again – and be prepared to go on doing so many times. There are dozens of instances of books being rejected time and time again before eventual acceptance and bestsellerdom, and even if the majority of such tales apply to fiction, it is also true of non-fiction. My own book, *An Author's Guide to Publishing*, of which well over 40,000 copies are in print, was turned down by a whole string of publishers before being accepted by Robert Hale Limited. On the other hand, if you get a series of rejections, especially if they are of the perfunctory form-letter variety, perhaps it will be time to look at your work again, both carefully and critically, in the hope that you may be able to see what is wrong with it – and since it will probably be some time since you last read it, you will come to it with fairly fresh eyes and may indeed see some faults which were previously overlooked.

Sometimes a publisher, when rejecting a book, will be moved to give the author a word or two of praise or encouragement. If you get a letter of that kind, you are entitled to take it at full face value and as a really good sign – publishers don't hand out compliments which they don't mean. Another possibility is that the rejection letter will suggest another publisher who might, so the editor thinks, be interested in your work. Cynics might fear that the editor's motive would be simply to waste a rival's time, but I doubt if that is likely to be true, and although editors aren't always right in their judgment of what will interest their competitors, you should feel very much encouraged

by such a suggestion.

Agents

There is a widespread belief among would-be writers that it is essential to have an agent because publishers take only those books which come to them from agents. It is not true. Publishers certainly take particular notice of books which agents submit to them, because they know not only that agents don't usually handle books which are devoid of merit, but also that they are likely to send them books which are particularly suited to their lists. However, the majority of editors are far too sensible to refuse to consider direct, unsolicited submissions, because by doing so they might easily miss a new bestseller. Moreover, there are distinct advantages for a publisher in signing up an unagented property, because the firm will usually in such cases control a number of rights (such as First Serial or Foreign rights) which would be retained by the agent if there were one, and if the publisher succeeds in selling any such subsidiary rights – and every effort will be made to do so – a share of the proceeds will go to him or her. In a recent survey conducted by the Society of Authors and the Writers' Guild in which well over a thousand published authors took part, less than half – in fact, about 41% – had agents, and although the figures included many writers of educational books, a field in which agents are infrequently involved, it does indicate clearly that a substantial majority of published authors get their books accepted and into print without the help of an agent.

Nevertheless, an agent is certainly a Good Thing for most writers. Let me amend that to say that a *good* agent is certainly a Good Thing, since some agents can be inefficient or even dishonest (which is also true of publishers and of authors and indeed of men and women in every walk of life). Members of the Association of Authors' Agents (indicated in the *Writers' and Artists' Yearbook* by an asterisk against the name of the firm) can be relied upon to be honest and efficient. That doesn't mean that non-member firms are necessarily to be shunned, especially since the AAA does not accept agencies as

members unless their turnover has reached a certain minimum figure and unless they have been established for a given period of time, so a new small firm may be excellent but may not qualify to be a member of the Association.

Good agents are worth having for a number of reasons – they know the market, and therefore which publisher might be interested in your work; they send the book out to potential publishers at their own expense; they negotiate a sale on your behalf, knowing what terms are appropriate and fighting to get you the best available; they check the contract to make sure that it is fair to you; they monitor the publisher's performance, watching to see that the terms of the contract are adhered to, that the royalty statements are correct and that payments are made on time; they sell certain subsidiary rights in your work on your behalf; they act as a mediator between you and the publisher in any dispute (an agent is on your side, but also understands, perhaps more clearly than you may do, the publisher's point of view), and if the argument becomes a battle, they wage the war on your behalf, standing between you and the publisher and thus protecting you from what could be a very unpleasant experience. Moreover, a large number of agents are also prepared to offer editorial advice to their established clients, and this is of immense value, both because it means that you have the chance of making improvements to your work before it goes to the publisher, and because the agent's input may be of better quality than that which you will get if you are unfortunate enough to have to work with an inexperienced or unsympathetic editor in the publishing house. Agents will often not only place your work but actually, as a result of their regular contact with publishers, find new work for their authors; this can happen, for instance, when a publisher tells an agent that he or she has been thinking of publishing a book on such-and-such a subject but has no particular author in mind to write it, and the agent says, 'I've got just the person who could do it for you,'; if the publisher knows the agent and can trust him or her to make a recommendation of that sort only on behalf of an author who really is suitable for the book, a

contract will often result. And a final bonus is that an agent may prove to be a real friend – someone who will listen to your problems, encourage you when you are feeling down, and cheer your success.

Agents normally charge 10% of any money that your work earns (although there are some who take 15%), this figure usually rising to 20% for the sale of any overseas rights, because British agents are represented in foreign countries by local agents, who also have to have their cut. VAT is also added to all these percentages. An increasing number of agents charge a reading fee for new authors, but once they have accepted you as a client the majority do not take a penny more until they have succeeded in placing the work and money is due to you.

So how do you find this desirable agent and persuade him or her to take you on? It's not at all easy, and if you are a beginner you may in fact find it far less of a problem to get a publisher than an agent. Agents tend to be very cautious about unpublished writers, and reluctant to represent them unless they can see those authors earning a minimum of, say, £5,000 a year from their writing (remember that out of their 10% agents have to pay the expenses of sending out books and correspondence, all the overheads of running an office, and their own salaries and those of their staffs). While you are sending out your letters of inquiry and your sample material to a number of agents (following the same procedure as you would with a publisher), you might just as well be saving time by approaching publishers.

You may wonder whether it is not vital to have an agent to guard against being cheated or at least unfairly exploited by an unscrupulous publisher. If you listen to authors talking shop you could easily come away with the idea that all publishers are the authors' worst enemies – mean, uncaring, constantly on the fiddle, and completely, utterly, absurdly inefficient. It really isn't true. Naturally there are often reasons for complaint – nobody is perfect (and that includes authors) – but a lot of the talk is simply like pupils grousing about the unfairness of teachers, or workers complaining of being exploited by the bosses, or a group of husbands comparing notes about the irritating

habits of their mothers-in-law. Leaving aside the inevitable occasional rogue, publishers don't cheat their authors. It doesn't pay them to do so. They may drive a hard bargain, but they do that largely because of the fact that 'a publisher's first duty towards his authors is to stay solvent,' as the great publisher Sir Stanley Unwin pointed out, and it's not easy to stay solvent in any business if you are over-generous to your suppliers. And the apparent inefficiency of publishers is often more the result of working in an extremely complex business than because of foolish incompetence.

It may be difficult to find an agent, but it is not impossible. Agents are listed in the *Writers' and Artists' Yearbook* and *The Writer's Handbook*, and the date when the firm was founded is given and some indication of its size (look for the numbers of members of the firm who are listed). Some of the newer, smaller firms are rather more willing to accept new clients than the bigger, older companies, so you could try them first. Any agent will also be very much more interested in you once you have got an offer from a publisher for your book – go to an agent at that stage, before signing the contract, and it is quite possible that you will be taken on. In any case, if you really have the potential to write very successful books, you will discover that agents can recognize talent just as quickly as publishers.

One word of warning: don't expect too much from an agent. He or she will probably do everything for you that I listed earlier, and this includes securing better terms from a publisher than you might get on your own, because he or she has an advantage over you in knowing quite a lot about the firm and how it operates, in understanding a great deal about the publishing business generally, and in being aware of what other publishers are paying for similar books. However, an agent won't make you rich – that's something you do for yourself by writing a bestseller. The improvement in terms that an agent can negotiate will probably not amount to much more than the 10% which he or she will take from your earnings, and because of that deduction you may even be better off on your own, especially if you are good at haggling and can

push your publisher to give you the best possible deal, and provided that you know when to stop the bargaining before the publisher decides that you are too greedy and calls it all off. And if you are unlucky enough to have a really diabolical publisher, the agent may not be able to solve the many problems which may ensue both before and after publication. However, don't forget all the other benefits which I have already mentioned.

Contracts

If a publisher accepts your work, you will probably receive a letter setting out some of the terms of the eventual contract, such as the territory, the advance, and the royalties. Straightforward and easy to grasp. However, the contract which follows is likely to be anything but that. Publishers' agreements nowadays are formidable documents, very difficult for the inexperienced to understand. Moreover, while the agreements which various publishers use all normally cover much the same points, the wording and the actual content of the clauses are invariably different. You will need specialist advice, which you may not be able to get entirely satisfactorily from your family solicitor, because although he will know the standard legal terms in the document, he may not know how publishing works, nor be familiar with trade jargon, nor know which provisions of the contract are fair and which are not. You should be able to rely on an agent, if you have one, to vet the agreement for you (indeed, many agents insist on using their own agreement forms rather than those provided by the publisher), but even with the best of agents you should not sign the contract unless you yourself understand it and are happy with its provisions.

The best place to go for advice is the Society of Authors, full membership of which is available to any author who has had a book published, while authors who have received an offer of publication can apply for associate membership, which will entitle them to consult the Society regarding their contracts. Similar facilities are offered by the Writers' Guild of Great Britain. Alternatively, my own books *An Author's Guide to Publishing* and

Understanding Publishers' Contracts may be helpful; the former includes a long chapter on contracts, covering all major points, while the latter is considerably more comprehensive and detailed, and includes specific warnings on wordings which an author is unwise to accept.

The contract which reaches you from a publisher is usually a printed form covering several pages. Since most books are signed up on slightly different terms, the form usually has a number of blank spaces which the publisher fills with such details as the royalty rates, the split of subsidiary rights moneys, and so on. Because the form is printed and looks very official, inexperienced authors often feel that it is immutable. This is not so. Most publishers will listen to requests from authors for changes to the agreement, and although they may not always give way, you should not be afraid to question anything which seems to you unreasonable or otherwise unacceptable. Don't be afraid that this will make the publisher decide not to publish your book after all; by the time that the contract has been prepared, he or she is likely to have done too much work on your book to want to give up just because you ask a few questions, and would only withdraw the offer if you became really tiresome and over-demanding.

Unless you are dealing with a very small new publishing house which has not yet established a reputation (in which case, although the chances are that everything will be entirely above board, it will be worth taking advice before committing yourself), you can be fairly certain that you are not going to be outrageously cheated. Publishers who treat their authors really badly don't usually stay in business very long. But while you will want to see that the financial arrangements set out in the agreement are acceptable, there are some other aspects of a contract which particularly affect the non-fiction author and should be looked at with care, including the clauses dealing with the delivery date, the warranty, proofs, revised editions, an option, and any which refer to consultation.

Delivery Date The delivery date is often important for a

non-fiction book because of the need to publish in time for an anniversary, for instance, or by some other fixed date. Make sure that the delivery date in the contract is acceptable to you. It will be much better to tell the publisher at this stage that you will need extra time to write the book, than to do so at the last minute. Once you have committed yourself to a delivery date, you should do your utmost to stick to it, and if you discover, part way through writing a book, that you are going to be late, you *must* let your publisher know.

Warranty　In the warranty clause the author guarantees that the work is original and that it contains no unlawful matter. You must take this very seriously. If you are successfully sued for plagiarism or libel or for any criminal matter in respect of what you have written, you and your publisher and the printer will probably be heavily fined, and there will be huge legal costs. Payment of all this money will be your responsibility. And there is also the trivial little matter of your book being withdrawn, and publishers looking extremely warily at anything else you write. If anything at all in your material might be potentially dangerous, do consult your publisher about it. The whole wording of the warranty clause is crucial, so even if you have nothing at all to fear, read it carefully and make sure that you understand its implications.

Proofs　You may be surprised that the clause concerning proofs should be singled out as one to be looked at with care, since it is normal practice for proofs to be sent to an author whose responsibility it is to read and correct them. The problem comes in some contracts which allow the author an extremely short time in which to turn the proofs around – a period with which it might be impossible to comply if it happened to coincide with your absence from home for a few days. Moreover, certain publishers also put in a nasty little piece to the effect that if you do not return the proofs within the given time they will be taken as approved as they stand. If the publisher refuses to alter such a clause, find out when proofs will come and plan your life, if you can, to fit in with the dates.

Revised editions　One of the standard clauses in a contract for a non-fiction book states that the author must,

if so required by the publisher, prepare an up-dated version of the work, and that if the author is unable or unwilling to do such revision, the publisher may employ someone else to undertake it. There are obvious dangers for authors if for some good reason they cannot prepare the required revision, because the work might be radically altered in a way of which they would disapprove. Some safeguards to give the author the right to approve revised editions need to be built in to such clauses.

Option The Society of Authors, the Writers' Guild and the Association of Authors' Agents are all opposed to option clauses giving the publisher the right to publish the author's next book. They are not encouraging disloyalty in authors, but believe that the publisher should earn the author's regard to the extent that he or she would not dream of going to a rival house with a new book. The only concession to which you might agree is promising to give the publisher first sight of your next work, with the provisos that a decision would be given within a limited period and that you would be free to accept or refuse the offer. But the best advice is to strike out without hesitation any option clause, however bland.

Consultation In recent years the Society of Authors and the Writers' Guild have been campaigning for the acceptance by publishers of what is known as the Minimum Terms Agreement (MTA), which attempts to lay down acceptable standards for advances, royalties and other payments to authors. But the MTA is not simply about money – it is equally emphatic about the author's rights, and especially the right of consultation on such matters as the blurb, the jacket design, the publication date, the print quantity, the plans for publicity and promotion, and being kept informed of subscription figures, subsidiary rights sales, reprints, remainder plans, and so on. Not all publishers have signed the MTA, but you are certainly entitled to expect some recognition of your right to consultation. At the same time, you will have to accept the fact, I am afraid, that 'consultation' does not often mean more than it says – you may be consulted, but you will not have a right of veto (at least, not until you get into the really big time). However, sensible publishers do

listen to comments from their authors, and even if your suggestions are rejected, at least the publisher will probably have to explain why. What is more, consultation also means the passing to you of information, which can be not only of considerable interest but may in some cases prevent too great a strain being put upon your relationship with the publisher; if you know, for instance, that your publisher does not intend to do anything in the way of publicity and promotion beyond trade advertising (which is often the case, and which he or she will say, with some truth, is the most effective way to get results), at least you won't be as bitterly disappointed as if nothing had been said and you were expecting a huge nationwide campaign.

Let me emphasize again that, before signing a publishing contract, you really do need to take advice from an authoritative source, or at the very least to consult my book, *Understanding Publishers' Contracts*, which was written precisely for authors who cannot easily pass the responsibility for checking their contracts to an agent or to an organization such as the Society of Authors.

Self-publishing

It is undoubtedly difficult for the majority of unknown writers to find publishers for their work, despite the fact that publishers are always, even in hard times, on the look-out for new talent, because old authors die or stop writing or go out of fashion, and life and our interests change, and new books are constantly needed. Many years ago, when conditions were rather easier, I wrote that there were no mute inglorious Miltons around, unless they really wanted to be mute and inglorious, and I stick by that even today. If you have talent of a high degree and if you persevere, then you will almost certainly get into print. You may say, however, that although you have persevered like nobody's business and most of your rejections praise your talent and seem to be genuinely regretful, no publisher will accept your book, apparently because they cannot see a large enough market for it. So what do you do? One possibility which you might

consider is self-publishing, but it does depend on having several hundred pounds that you are prepared to spend, with the hope, but no guarantee, of getting it back.

Self-publishing used to be very much looked down on as the last resort of failed writers who had enough money to feed their vanity by publishing their little books of poems and presenting them to their friends and relations. At least those self-published authors had the sense to avoid the vanity publishers (see pp.103–4), and if they managed to sell any copies of their books, they got some, or even all, of their money back. Nowadays, the stigma has gone. Self-publishing is flourishing, and many highly respected and much published authors have themselves brought out a volume of some kind which no publisher would take on because the market appeared to be too small. And many of them have been successful too.

One of the major problems which a commercial publisher faces in catering for a limited market is that the only solution which makes economic sense is to price the book very highly; but the economic sense immediately turns into nonsense, because the high retail price inhibits sales to a disastrous extent. The problem is that the publisher's receipts, after allowing for the bookseller's discount, have to cover not only the manufacturing cost and the author's royalty, but the firm's overheads (often very high, with expensive offices, a large staff, and all the paraphernalia of commercial life) and a profit; this usually means multiplying the unit manufacturing cost by at least five in order to calculate the retail price. The self-published author, on the other hand, usually has minimal overheads, can often get away with smaller discounts for the bookseller than a commercial firm would have to give (and will, in any case, sell quite a large number of the books directly to the public at the full price), and may not be overmuch concerned about making a profit or even taking a royalty on the sales, with the result that it may not be necessary for him or her to do more than double the manufacturing cost to fix a retail price which will seem quite modest. (I would suggest, however, that you should not pitch the figure too low – most people are used to what books cost, and if they are going to buy your book at

all, will fairly willingly part with what seems to them to be a reasonable sum.)

Your first problem if you intend to go in for self-publishing is to find a printer. It's not difficult. Look in the Yellow Pages, and you will undoubtedly discover several within easy reach of your home. Some may be 'jobbing' printers, which usually means that they do not have the facilities for producing a book, their forte being the printing of tickets, leaflets, programmes and the like. You really need a rather bigger firm than that, so look for those whose advertisements suggest wider capabilities. Your abilities may extend to designing your book yourself, including the jacket – indeed, you may be a desktop publisher who can take camera-ready copy to the printer, ready for press – but do not despair if your book consists at this stage only of an ordinary typescript and if you have no skill as a designer and wouldn't recognize Baskerville 11 pt (a variety of type and its size) if it came up and hit you. Many printers will be ready to help you out of all your difficulties with good advice or will even take on the work for you. Do shop around – prices and the services you get for them can vary considerably. The unit costs you are given will depend on the number of copies you print – the more you decide upon, the cheaper each copy will be, but beware of being tempted into printing more than you can ever hope to sell.

The distribution and sale of the book is the self-publisher's biggest problem. Most major publishers have a sales force of representatives who visit booksellers and wholesalers, persuading them to take quantities of their books for sale, eventually, to the public. They also have facilities for getting their products to overseas outlets. The self-publisher has to do all this alone, and short of travelling the entire country to visit bookshops and finding out whom you should see in the head-offices of the big chains (where central buying is often the rule), you are not going to get a nationwide distribution. It can be done, but it's jolly difficult, and you'll probably end up a physical and nervous wreck. However, there are certain things which are within the capabilities of most authors: you can at least visit the booksellers in your immediate

vicinity in the hope that they will put your book on sale;
you can find out the names and addresses of the County
Librarians and solicit orders from them by post; you can
dragoon your relations and friends into buying copies,
and you may also be able to persuade some of them to act
as your representatives, perhaps getting *their* booksellers
to take copies; and you may be able to stimulate sales if
you have access to a mailing list of people who are likely to
be interested in the book.

The path of a self-publisher is strewn with rocks, some
of which may seem insurmountable, quite apart from a
number of minor hazards which I have not yet mentioned,
such as the need to obtain an ISBN (International
Standard Book Number) for your book, to register it on
publication with J. Whitaker & Sons, Ltd (the firm which
maintains and publishes lists of books in print), and to
deposit copies with the 'copyright' libraries (a legal
requirement). You will also need to be aware that when a
bookshop takes your book, it will probably be 'on sale or
return', meaning that you get paid by the bookseller only
for copies that have been sold, and after the event. You
will also need to be aware of the complications added by
Income Tax and VAT. There is much to learn.

Several organizations exist which can help you not only
with all these problems, but also in providing advice about
finding a printer, designing the book, how many copies to
print, and so on (some of them advertise regularly in
magazines for writers). Most of them will do a good job for
you, but naturally you will have to pay for the services
they provide. A cheaper method is to do it all yourself by
following the instructions given in one of the books on
Self-Publishing which are available – *Publishing Your Own
Book* by Jon Wynne-Tyson and *How to Publish Yourself* by
Peter Finch can both be recommended.

Copyright

Copyright is an extremely complex subject, which has not
been simplified by the Copyright, Designs and Patents Act
of 1988. However, for most practical purposes, anything
that you write is your copyright as soon as you have

written it, and the copyright will extend in most cases for fifty years after your death (or fifty years after publication if the book is brought out posthumously). The one important exception to this rule is that if you are a full-time employee and your job, or part of it, is to write material for your employer, the copyright will belong to the employer. So the reports and feature articles produced for a newspaper by a journalist working full-time and as an employee of that newspaper are the newspaper's copyright. In the same way the publicity material which a publisher's employee writes is the publisher's copyright.

However, in most cases the author of a book is not employed by the publisher – a commission to write a book for a publisher does not constitute employment – but is an independent freelance, and more than that, an equal partner with the publisher (if not in power, at least in the fact that each has something to offer the other). So the copyright is yours, and no one may publish it or use it in any way without your permission, which usually involves the payment to you of a suitable fee. When your work is taken by a publisher, the standard arrangement is that you licence the publisher to publish the book and to negotiate the sale of various subsidiary rights; appropriate sums, the details of which will be specified in the contract, will be paid to you in respect of sales of the books or of rights. However, the copyright in the work will remain yours absolutely – or should. Never surrender your copyright. If you are faced with a publisher who will not publish your book unless you give up your copyright, it may not be easy to resist the offer, especially since your acceptance of the terms means that your work will appear in print and that you will receive what one hopes is a reasonably substantial sum in payment for the copyright. But think long and hard before you give in, and take advice if you possibly can. If you surrender your copyright, even if it seems that you are well paid for doing so, the purchaser can then make any use of the material, exploiting it to the full and perhaps printing many, many editions and selling a number of subsidiary rights, without paying you a single penny more.

Although your written work is copyright, there is no

copyright in ideas, and many beginners are very worried that if they submit a project to a publisher it is likely that, because they are beginners, the material will be rejected, but that the publisher will then pinch the idea and get an established writer to produce the proposed book. From time to time one hears stories of this actually happening, although I would suggest that on careful examination not all of these accusations against publishers will hold water. There are a few rogues about, but publishers in general do not pinch other people's ideas. You have to realize that very few ideas are so extraordinary that they will have occurred only to you. By the time that you submit your proposal to the publisher, another author may already have had the same thought and have been signed up – there are many different possibilities of this kind. In the end, the risk of having your idea pinched is one that you simply have to run. However, if you are still worried, you can take certain precautions, putting a copyright notice with the copyright symbol, your name and the year (see p.95) on all your work, recording the dates when you send material out, depositing a copy of the work with your bank in a sealed and dated cover, and so on and so forth. It will still be very difficult to prove your case if you believe that your idea has been pinched, and it is probably going to be a great deal of trouble for nothing; most professional writers don't bother.

As has already been explained, there is no copyright in titles, either. You should, however, avoid using a title which is already well known, because you could be sued for passing off, which means attempting to fool people into buying your book on the assumption that it is the famous one (mind you, your publisher would be pretty silly to let the book go through with a celebrated title). Even if you have no intention of using a familiar title, you will probably hope not to duplicate one that has already appeared, especially if the book which it graces is still in print. It may be a good idea to check in a library or get a friendly bookseller to look through the microfiches of books in print to see whether your choice has already occurred to someone else. Of course, if you are writing a biography of, let us say, Florence Nightingale, there is no

reason why you should not call it *Florence Nightingale*, even if several earlier biographies of the lady have had the same title – indeed, it may be preferable to stick to the plain and simple in such cases, rather than look for something high-falutin like *The Angel of Scutari*.

Appendix

Organizations for Writers

The Society of Authors
Founded in 1884, the Society of Authors exists to further the interests of authors and to defend their rights. As well as doing so on an individual basis, it negotiates with the Government (over such matters as VAT and PLR), with publishers and with any other bodies concerned with authors. It offers free legal and business advice to its members (including clause-by-clause vetting of contracts), plus a large number of other benefits, among which are medical insurance and pension schemes.

The Society is a recognized trade union, but is not affiliated to the TUC, and is completely non-political.

The qualification for full membership is to have had a book commercially published. Associate membership is available to those who have a typescript accepted by a publisher but have not yet signed the agreement, and to certain writers working in other media. Details may be obtained from: The Membership Secretary, The Society of Authors, 84 Drayton Gardens, London SW10 9SB. Telephone: 071-373 6642.

The Writers' Guild of Great Britain
Originally called the Television and Screenwriters' Guild, this organization has in recent years widened its scope to include representation for all kinds of authors, and it has a special Books section. Nevertheless, it is still primarily orientated towards the film, television, radio and theatre writer. It offers similar facilities to those available from the Society of Authors.

The Guild is a recognized trade union, and while it is not a political organization, unlike the Society of Authors it is affiliated to the TUC and to certain other individual unions in the Entertainments business.

Membership is open to any writer who has had work commercially published, broadcast or performed, and to those whose work has been accepted but who have not yet signed an agreement. Details are available from the Membership Secretary, The Writers' Guild of Great Britain, 430 Edgware Road, London W2 1EH. Telephone: 071-723 8074.

Public Lending Right Office
Authors are entitled by law to payment, funded by the Government, when their books are borrowed from public libraries. All such payments belong to the author alone, and are not shared with the publisher or even with the author's agent.

The responsibility for registering for PLR is the author's, rather than that of the publisher or the agent. For details write to: Public Lending Right Office, Bayheath House, Prince Regent Street, Stockton-on-Tees, Cleveland TS18 1DF.

The Authors' Licensing and Collecting Society
Set up by writers in 1977, this organization collects sums of money due to authors for certain subsidiary rights in their works, which for special reasons cannot be paid to the authors directly, such as PLR from foreign countries, photocopying fees, royalties on cable transmission of television programmes, etc.

ALCS is the joint owner, together with the Publishers Licensing Society, of the Copyright Licensing Agency (CLA), which exists to license and collect fees from schools, universities, industry, government offices, etc, in respect of the photocopying of copyright material. The moneys are then split between authors, represented by ALCS, and publishers.

For details of ALCS, write to The Membership Secretary, ALCS, 33/34 Alfred Place, London WC1E 7DP. Members of the Society of Authors and the Writers' Guild are given free membership of ALCS, and are automatically entered on their books.

PEN – The World Association of Writers
This international organization was founded in 1921 to promote friendship and understanding between writers and to defend freedom of expression within and between all nations. P.E.N. stands for Poets, Playwrights, Editors, Essayists, Novelists, but membership is open to any writer or translator (or indeed anyone who works in virtually any capacity in the book business), who is of good standing and subscribes to the Association's fundamental principles. One of PEN's most

important concerns is to campaign for the freedom of writers who are imprisoned or otherwise persecuted for views which do not coincide with those of the régimes under which they live. Details may be obtained from: PEN International, 7 Dilke Place, London SW3 4JE. Telephone: 071-352 6303.

Writers' Conferences

Many residential courses for writers take place up and down the country. The most popular and longest-established of these is the Writers' Summer School, which is held at Swanwick in Derbyshire for a week every August. Details may be obtained from: Mrs Philippa Boland, The Red House, Mardens Hill, Crowborough, East Sussex TN6 1XN. Telephone: 0892 653943.

Other popular gatherings include:

Writers' Holiday, held in Caerleon, Gwent, in late July. For details write to Mrs D.L. Anne Hobbs, 30 Pant Road, Newport, Gwent NP9 5PR.

Southern Writers Conference held at Chichester, West Sussex, in mid-June. For details write to Ms Ann Hutton, 6 Blandford Road, London W4 1DU.

Writers' Weekends, held at Scarborough, North Yorkshire, in April and November. For details write to Mrs Audrey Wilson, 7 Osgodby Close, Scarborough, North Yorkshire YO11 3JW.

SAMWAW (South and Mid-Wales Association of Writers) Weekends, held at Cardiff, South Glamorgan, in May and September. For details write to Mrs Marguerite Prisk, 48 Baron Road, Penarth, South Glamorgan CF6 1UE.

The Arvon Foundation

This organization offers people of all ages over sixteen the chance to meet, talk and work in an informal way with practising artists. The Arvon centres provide a full programme of five-day courses in various fields of writing and related art forms. Details may be obtained from: The Arvon Foundation, Lumb Bank, Heptonstall, Hebden Bridge, West Yorkshire HX7 6DF, or from The Arvon Foundation, Totleigh Barton, Sheepwash, Beaworthy, Devon EX21 5NS.

Some Other Useful Organizations

The Association of Authors' Agents, 79 St Martin's Lane, London WC2N 4AA. Telephone: 071-836 4271.

The Authors' Guild of Ireland Ltd, 282 Swords Road, Dublin 9. Telephone: 375974.

Book Trust, Book House, 45 East Hill, Wandsworth, London SW18 2QZ. Telephone: 081-874 4790.

Book Trust (Scotland), 15a Lynedoch Street, Glasgow G3 6EF. Telephone: 041-332 0391.

British Science Writers, Association of, c/o British Association for the Advancement of Science, Fortress House, 23 Savile Row, London W1X 1AB. Telephone: 071-494 3326.

Broadcasting Group, The Society of Authors, 84 Drayton Gardens, London SW10 9SB. Telephone: 071-373 6642.

Children's Writers and Illustrators Group, The Society of Authors, 84 Drayton Gardens, London SW10 9SB. Telephone: 071-353 6642.

Christian Writers, The Fellowship of, c/o She-Dy-Vea, 151a Bedford Road, Marston Morteyne, Beds. MK43 0LD. Telephone: 0234 767470.

Educational Writers Group, The Society of Authors, 84 Drayton Gardens, London SW10 9SB. Telephone: 071-353 6642.

Indexers, The Society of, c/o 16 Green Road, Birchington, Kent CT7 9JZ.

Medical Writers Group, The Society of Authors, 84 Drayton Gardens, London SW10 9SB. Telephone: 071-353 6642.

Scientific and Technical Authors' Group, The Society of Authors, 84 Drayton Gardens, London SW10 9SB. Telephone: 071-353 6642.

Scientific and Technical Communicators, The Institute of, PO Box 479, Luton, Beds, LU1 4QR. Telephone: 0582 400316.

Women Writers and Journalists, The Society of, c/o 110 Whitehall Road, Chingford, London E4 6DW. Telephone: 081-529 0886.

Travel Writers, The British Guild of, c/o Bolts Cross Cottage, Peppard, Henley-on-Thames, Oxon RG9 5LG. Telephone: 04917 411.

The Regional Arts Associations

Arts Board: North West, 12 Harter Street, Manchester M1 6HY.

East Midlands Arts, Mountfields House, Forest Road, Loughborough, Leicestershire LE11 3HU.

Eastern Arts Association, Cherry Hinton Hall, Cherry Hinton Road, Cambridge CB1 4DW.

London Arts Board, Coriander Building, 20 Gainsford Street, London SE1 2NE.

North Wales Arts, 10 Wellfield House, Bangor, Gwynedd LL57 1ER.

Northern Arts, 9-10 Osborne Terrace, Newcastle-upon-Tyne NE2 1NZ.

South East Arts, 10 Mount Ephraim, Tunbridge Wells, Kent TN4 8AS.

South-East Wales Arts, Victoria Street, Cwmbran, Gwent NP44 3YT.

South West Arts, Bradninch Place, Gandy Street, Exeter, Devon EX4 3LS.

Southern Arts, 13 St Clement Street, Winchester, Hants S023 9DQ.

West Midland Arts, 82 Granville Street, Birmingham B1 2LH.

West Wales Arts, Red Street, Carmarthen, Dyfed SA31 1QL.

Yorkshire and Humberside Arts, Glyde House, Glydegate, Bradford, West Yorkshire BD5 0BQ.

Bibliography

Anderson, M.D., *Book Indexing* (Cambridge University Press, 1985)

Finch, Peter, *How to Publish Yourself* (Allison & Busby, 1987)

Hines, John, *The Way to Write Non-fiction* (Elm Tree Books, 1990)

Hoffmann, Ann, *Research for Writers* (A & C Black, 1992)

Legat, Michael, *An Author's Guide to Publishing* (Robert Hale, 1991)

Legat, Michael, *Understanding Publishers' Contracts* (Robert Hale, 1992)

Scarles, Christopher, *Copyright* (Cambridge University Press, 1980)

Turner, Barry (ed.), *The Writer's Handbook* (Macmillan, published annually)

Writers' and Artists' Yearbook (A & C Black, published annually)

Wynne-Tyson, Jon, *Publishing Your Own Book* (Centaur Press, 1989)

Index